The Art of Scenic Photography

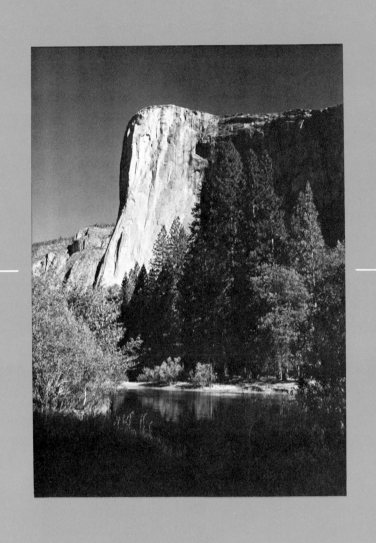

The Art of
SCENIC
PHOTOGRAPHY

Tom Grill
and
Mark Scanlon

AMPHOTO
American Photographic Book Publishing
An imprint of Watson-Guptill Publications
New York, New York

To our camping companions:
Christopher
&
Derek and Brian

First published in New York, New York, by American Photographic
Book Publishing: an imprint of Watson-Guptill Publications, a division
of Billboard Publications, Inc., 1515 Broadway, New York, NY 10036

Designed by Tom Grill.

Library of Congress Cataloging in Publication Data

Grill, Tom, 1944–
 The art of scenic photography.

 Includes index.
 1. Photography—Landscapes. I. Scanlon, Mark,
1945– II. Title.
TR660.G7 778.9′36 82-1657
ISBN 0-8174-3538-7 AACR2

Manufactured in the United States of America

First Printing, 1982

1 2 3 4 5 6 7 8 9/87 86 85 84 83 82

CONTENTS

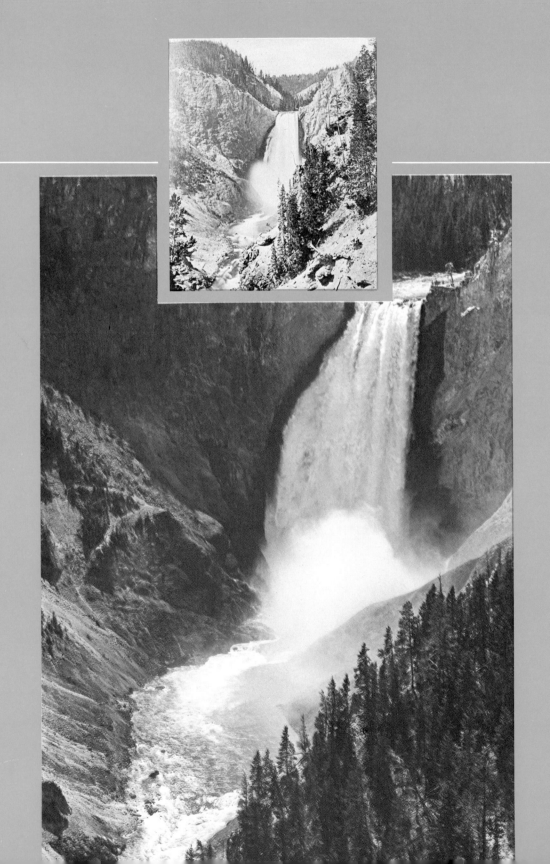

INTRODUCTION

In 1871, the photographer William Henry Jackson embarked on a historic expedition to the barely explored western regions of the United States, an expedition that was to profoundly influence both the practice of photography and the politics of an emerging nation. As a member of a geological survey team, Jackson had the task of bringing back to the eastern citizenry visual proof that the awesome natural phenomena previously only heard about really did exist.

Although Jackson was an accomplished professional photographer, the challenge he undertook was formidable. Roads in the West were almost nonexistent, those maps that were available were often inaccurate, and the terrain over which the expedition proposed to travel was intimidating. Moreover, the goal, to reach and survey the area that is now Yellowstone National Park, meant a journey in and around the high mountain ranges that line the Continental Divide.

Jackson's task was complicated by the demands of the wet collodion process, in which glass plates must be carefully coated immediately before exposure with a light-sensitive fluid. Jackson had to transport hundreds of the fragile plates in the back of a covered wagon and sometimes on foot, into nearly inaccessible areas. The plates had to be coated with the collodion solution in total darkness, wrapped to exclude light, carried quickly to the camera—sometimes hundreds of yards distant—and exposed, then transported back to the "dark box" and developed, all before they had a chance to dry. Each exposure usually required at least three-quarters of an hour of concentrated, exacting effort.

Although Jackson fully intended to realize a profit from his photographs, money did not provide his sole motivation. He enjoyed outdoor living, and photography was as much a hobby to him as a business. Some people might dismiss his efforts for being "commercial," but given the aesthetic sensitivity his work displays, such a criticism seems unfair.

In Jackson's day, the act of obtaining a correct exposure and an acceptable print required a substantial amount of experience and skill. Because light meters did not exist, Jackson had to estimate light intensities and then consult tables to relate his estimate to the light-sensitive material he was using. A mistake meant an unusable negative. Since enlargers did not exist, the size of the prints was determined by the size of the negative from which the print was made.

Jackson's photographs were limited by his resources and perhaps by

Inset: Yosemite Falls, ca. 1861, by C. E. Watkins. Albumen print contact printed from an 18 × 22 in. wet collodion plate. The large photo is the same scene rephotographed one-hundred twenty years later on 35mm film.

his own shortcomings as an artist. His assigned task was merely to create a likeness of the territory. Why is it, then, that despite the technical limitations imposed on him by his medium, many of Jackson's photographs, while not master-pieces, far outshine the vast majority of the photographs being taken today of exactly the same scenes? How is it that modern photographers, supported by vastly improved film and equipment, often fall short of the mark he set?

Part of the answer, of course, can be attributed to individual differences in aesthetic sensitivity. Jackson was fortunate in having a natural "eye" for a pleasing composition, an ability many people do not share. Beyond that, however, we believe part of the reason that scenic photographs today are often sterile is the very accessibility of the scenes being photographed. We in modern times have become inured to the grandeur because we have seen it all before.

For example, a sharp contrast exists between the Yellowstone of Jackson's era and the Yellowstone of today. Highways now line the route he traveled by wagon and on foot. The same vantage points he struggled to attain while carrying a heavy burden of equipment can now be reached almost without effort in a car. In some instances, the exact photograph he took can be duplicated without the photographer even having to leave the automobile. To the same extent Yellowstone was inaccessible in Jackson's time, today it is accessible to almost anybody.

A comparison of the capabilities of photographic equipment reveals equally great differences. Modern electronic circuitry has so simplified the process of attaining a correct exposure that many photographers cannot lay claim to having even a fundamental understanding of the relationship between light and film—and many do not care. They are content to produce nothing more than a likeness of the scene before their eyes.

The contrast between Jackson and many modern photographers became apparent to one of us (T.G.) during a trip to Yellowstone National Park. At a scenic overlook beside a main road through the park, dozens of cars had stopped and scores of people were surveying the scenery and taking photographs. A century earlier, Jackson had stood on this same spot and captured a beautiful, evocative image. The modern-day photographers, in their haste to move on to other vistas, allowed themselves enough time only to point and shoot. They seemed to have decided that, since automatic controls assured a correct exposure, there was no need to do anything but look through the viewfinder, take the picture, and leave.

Not everyone who uses a camera aspires to taking great photographs, of course, but many camera owners *are* interested in using photography to record the beauty of natural scenery. Many of these people do not realize that part of Jackson's success actually resulted from the primitive nature of his equipment, which forced him to control every aspect of producing a photograph carefully. The modern photographer needs to understand that the benefits of

technological improvement have not eliminated the need to master the underlying intricacies of photography. To take exceptional photographs, the modern photographer must understand photography just as thoroughly as Jackson did, even though the need for that understanding is no longer obvious.

In *The Art of Scenic Photography* our goal is to present on how scenic photography can be elevated beyond simply being a means for producing postcardlike representations to becoming a means for creative expression. Our intention is to elucidate, through words and illustrations, both the technical underpinnings and the aesthetic implications of creative landscape photography and thus to help photographers develop their ability to use scenic photography as an artistic outlet.

In Section One we offer some thoughts and opinions about the nature of the creative impulse as it relates to photography, and we discuss the critically important concept that all photographs are really records not of physical objects but of *light*. Consequently, the prerequisite to skill in photography is a sensitivity to the nuances of light.

The technology of photography has progressed so rapidly in recent years that the amount of available equipment from which a photographer can choose is overwhelming. In Section Two we categorize the major types of equipment and discuss the important aspects of each.

Without technical skill, creative expression is stifled. In Section Three we discuss some of the fundamental skills of scenic photography, with the goal of helping photographers develop a sound overall technique. We explain how the effects possible with large-format cameras can be duplicated in many cases with small- and medium-format equipment, which is of special interest to modern photographers.

A hallmark of the expert landscape photographer is the ability to control the tonal values of a scene so as to render them in a print exactly as he wants them. The well-known Zone System, useful in controlling tone and contrast with large-format cameras, has some serious shortcomings when applied to small and medium formats. In Section Four we introduce our Value Range System of contrast control, which is designed not only to accommodate but even to exploit the unique characteristics of small- and medium-format cameras.

The setting of a photograph is especially important in scenic photography. In Section Five we discuss aspects of how specific conditions affect the setting of a photograph and suggest ways these conditions can be used effectively to support a photograph's message or even to become the message itself.

By its very nature, creativity is subjective and personal. To help readers understand some of the thought processes and decisions that contribute to the final form a photograph takes, some comments are written in the first person; these represent T.G.'s thoughts about photography. Both of us hope the reader will find these discussions, as well as the rest of the book, interesting, instructive, and valuable. □

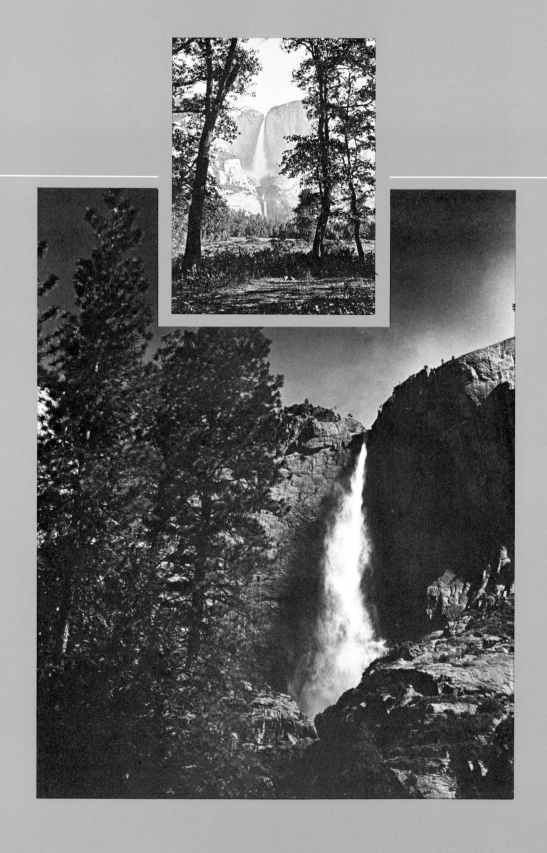

The creative photograph is a personal, subjective representation of a particular photographer's view of the world, artfully expressed on paper by means of carefully controlled light values.

1. LIGHT

Why are some photographs works of art while others, taken at the same time and place, are not? Why are some people satisfied if their photographs are merely correctly exposed and present an accurate representation of the scene in front of them while other people are painstaking in the pursuit of something more?

The answer lies in the *intent* of the photographer. Photography can be a means for documenting the way things look, or photography can be used as a means for exploring thoughts, feelings, or reactions and for communicating a personal outlook to others. For the first group, the camera serves as simply a device for record-keeping; for the second group, the camera functions as an instrument of creative expression.

Natural scenery has served as the subject of photographs since the earliest days of photography, and to this day it continues to appeal to both photographers and those who enjoy looking at photographs. Indeed, some of the most famous photographs ever taken are of natural vistas. The reasons for this popularity are complex, but surely they derive, at least partly, from an instinctive desire to understand our natural environment and our relation to it. Some people express this desire by forsaking the creature comforts of the modern world and "returning to nature"; other people express it through outdoor recreation; and still others express it politically, by actively seeking to protect the earth's natural heritage. The photographer satisfies this desire by capturing images of nature on film.

But merely using a natural scene as the subject of a photograph does not insure that the photograph will be great—or even good. No matter how technically correct it may be, a photograph that does nothing more than demonstrate the way a scene looks is sterile. This is not to suggest that *every* photograph could be or should be a work of art. Every photographer should remember, however, that a beautiful scene does not automatically result in an artistic photograph. A continuum exists along which any photograph can be placed. At one extreme lies the commonplace photograph, devoid of any real creativity and serving no real purpose other than to show that a particular place exists; at the other extreme lies the purely artistic photograph, owing as much, or even more, to the creative contributions of the photographer as to the literal contents of the scene itself. In between lie all the various degrees of "art" that technical competence and creativity can generate.

For a photograph to have artistic

Inset: Great Falls of the Yellowstone, 1872, by William Henry Jackson. Albumen print made from a wet collodion plate. The large photo was taken with a Leica M2 camera from a roadside vista located almost exactly where Jackson stood to take his photograph. Today, the site is within the confines of Yellowstone National Park.

merit, it must surpass mere technical competence and even mere beauty. The photograph must in some way incorporate the feelings and opinions of the photographer. The photographer must have used equipment and skill as a means of interpreting the scene so that the viewer understands more about the subject than the fact that it simply exists. That is, an artistic photograph communicates with a viewer and makes an impression. Therein lies the difference between the most beautiful postcard and the most elementary "work of art." The postcard may recall and duplicate the scene, but the postcard says little or nothing about how the photographer felt about that scene. Presumably the photographer, too, thought that the scene was beautiful, but beyond that, conclusions are difficult to draw.

Having the desire to communicate through photography is not in and of itself sufficient to insure success, however. A photographer must also possess the technical skill necessary to translate his thoughts or feelings effectively into a photographic image. Likewise, technical proficiency cannot stand alone but must be coupled with imagination and creative talent. When the two meld, when the vision of the photographer blends with the ability to commit the vision to film, great photographs result.

Light, in and of itself, has no meaning. By making choices and appropriate manipulations, the photographer instills the necessary meaning into light, the "alphabet" of photography. The meaning may be no more than the feeling evoked in a viewer by a particular pattern or color; but the meaning exists as a result of the purposeful actions of a human being trying to inject in a photograph a content beyond that provided by the subject alone.

For example, a photographer who works for an insurance company and is assigned to investigate an auto accident will take a dry, factual photograph intended only to provide a record of the damage done. A skilled newspaper photographer might choose an angle that would tell the story of the accident and therefore take a photograph in which the presence of the sharp curve that caused the damage receives primary emphasis, with the car playing a secondary role. An artistic photographer might concentrate on a small section of torn metal that formed an interesting pattern, and the car itself might be unrecognizable.

Each of the three resulting photographs will have a purpose, but the level of meaning will be different in each. The insurance photograph will be recognizable as being of a car, but its meaning will be limited to its *literal* subject. The journalistic photograph will have more content—in the form of a "story"—and therefore represent a higher level of *artistic* meaning (although the photograph might not properly be characterized as "art"). The abstract (third) photograph, even though it may bear no resemblance to the original subject at all, nonetheless will have *artistic* meaning in that it will effectively transmit the thoughts, feelings, or outlook of the photographer.

Thus, meaning in a photograph can be *intellectual*, as when the photographer wishes to make a political comment (on pollution, for instance); *emotional*, as when the goal is to

express sadness, or joy, or gentleness, etc.; *philosophical*, as in, perhaps, a statement about the unity of man and nature in the cosmos; or *abstract*, as when the sole message is contained in the interplay of lines as they create interesting or pleasing forms, shapes, and patterns.

In a sense the artistic photographer's role is that of interpreter. The interpretation need not be especially grand, but as it becomes more sophisticated, the level of artistry is likely to increase. Consider, for example, a photographer in a desert. If he is stranded, has little water, and faces a long, uncomfortable walk out, he might view the scene with anxiety or fear or dread. On the other hand, his impressions might merely be of vastness or of the pleasing lines formed by sand dunes. In either case, his point of view should be apparent, at least subtly, in the photographs he takes. The postcard photographer would leave the scene with essentially the same photograph, regardless of the way he personally felt at the time. The creative, sensitive photographer would not be satisfied until he was certain that his photographs reflected something of himself, that they interpreted the scene in some manner he found meaningful.

Beginning photographers often do not know how to recognize when they are interpreting a scene and when they are not. The surest method is simply to be aware in photographic terms of how one is reacting to a scene. When a photographer has come to terms with a scene, he finds it easy to make specific choices about how he wants to take the photograph. He searches for the right angle, or the right lighting, or the right lens, or the right film format, and is not satisfied until he finds it. Some techniques or items of equipment seem right, and some seem wrong.

The photographer who wants to express his feelings about the vastness of the desert does not reach for a telephoto lens but, understanding the technical and creative capabilities of his equipment, selects a wide-angle lens. The photographer who stands in the middle of the desert unable to determine the best lens to use has not decided—either intellectually or emotionally—how he feels about the scene, and the photograph will reflect this indecision.

Admittedly, fresh interpretations are not easy to achieve. Photography has become such a pervasive part of modern life that most photographers see as much through the eyes of other photographers as through their own, particularly in scenic photography, where traditional approaches have exerted a strong influence. Techniques that to early photographers represented personal interpretations are mimicked again and again unknowingly by modern photographers who have become saturated by "conventional" images.

For instance, today many photographers consider extreme sharpness of detail to be an absolute requirement of a "good" scenic photograph. This bias is the result of many years during which the best-known landscape photographers felt that their personal interpretations of outdoor scenery could be conveyed best if the images were as sharp as camera technology would permit. Specifically, the "Group *f*/64" photographers of the early 1930s established the standard by which many people still judge outdoor photo-

graphs. Group f/64 was an informal circle of such now famous photographers as Ansel Adams, Edward Weston, John Paul Edwards, and Imogen Cunningham. They insisted upon the importance of certain materials and methods in scenic photography: a view camera, super-speed panchromatic and panatomic films, pyro-soda developer, K1 and K2 filters for tonal correction, glossy paper, plain white mats, and dry mounting. Today, as the result of the heavy influence exerted by Group f/64, many photographers assume that anything other than a sharply detailed image is unacceptable in scenic photography; they view and interpret a scene not through their own eyes but through the eyes of those who have preceded them.

Certainly there is nothing inherently wrong with a scenic photograph being sharp. A problem presents itself only when that sharpness does not reflect the perceptions of the individual photographer or when a photographer unthinkingly dismisses a particular style or technique simply because others have not used it before.

Excellent reasons often exist for straying from the rigid standards of classical sharpness, if only because modern small-format cameras are less able to easily render sharp images than their larger counterparts. Indeed, the modern small-format camera so popular today is no match for a large-format view camera in terms of sharpness and image control but more than compensates by being much more maneuverable and versatile. The contemporary photographer who can exploit the full capabilities of small-format cameras may not produce images that are as sharp as some people have become accustomed to seeing, but as long as he is willing to free himself from arbitrary conventions, he has a great potential to produce outstanding, artistic scenic photographs.

Light

The ability to speak the "language" of photography is critical for any creative photographer, and no element of the language is more important than light. Any skilled photographer must have a feeling for the way the light in a scene will appear in a photograph, but scenic photographers must be especially sensitive. In the studio, a photographer has complete control over light. Even when taking a portrait outdoors, a photographer can use electronic flash and reflectors to manipulate light to conform to his needs. When the subject of a photograph is a panorama, however, control is limited to changing the angle or waiting until another time of day. Insensitivity to light will therefore almost invariably result in inferior photographs, no matter how creative the photographer.

Sensitivity here refers to an ability to appreciate the nuances of light in such a way that light becomes an effective element in the language of photography. Photographers who lack an acute awareness of light are content to let a light meter do the thinking: they point the meter, follow its indications religiously, and take a photograph perfunctorily. Often,

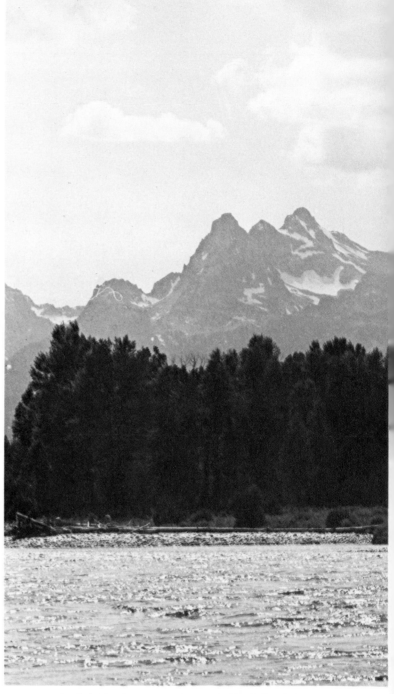

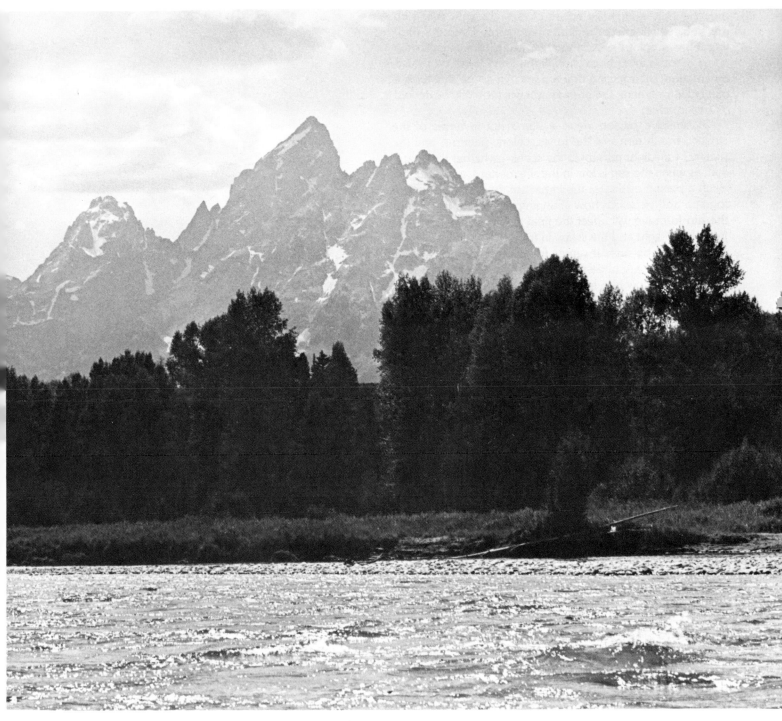

The feeling evoked by most scenic photographs depends very much on the quality of the light illuminating the scene. In many instances, the success of a photograph is directly related to light quality.

The photograph at left is compositionally strong and shows good detail, and would probably be quite appealing were the quality of the light in the scene better. As the photograph stands, however, the harsh light originating from behind the camera produces a stark feeling and obscures the ruggedness and distance of the mountains.

The feel of the photograph above, on the other hand, depends almost entirely on the quality of light present. Without the band of brightness formed by sunlight reflecting off the water and the feeling of distance produced by backlight filtering through atmospheric haze, this photograph would have been exceptionally dull. Indeed, the quality of the light in this photograph is almost solely responsible for generating its message.

PORTFOLIO I

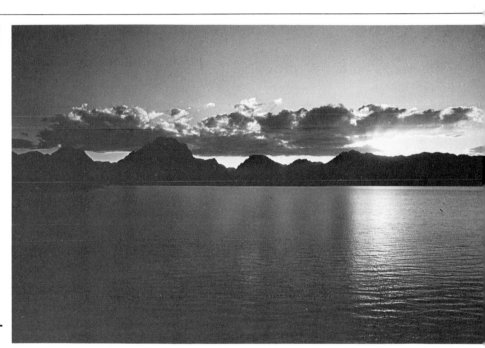

STUDIES IN LIGHT

*M*y starting point for a photograph is light. Once I see a type or quality of light that I find interesting, the subject almost falls into place. The subject really just serves as a means for composing the light.

Light filtering through mist possesses a unique quality that is sometimes difficult to capture on film.

In the upper photograph, the mist was so thin that detail was faintly visible in the background behind the tree. A normal exposure would have produced a gray background. Overexposing the frame slightly preserved the overall white feeling of the scene.

In the lower photograph, mist created a condition where the scene was too uniform in tone. The frame was exposed exactly in accordance with the meter reading, but the foreground was darkened during printing to make the buildings stand out.

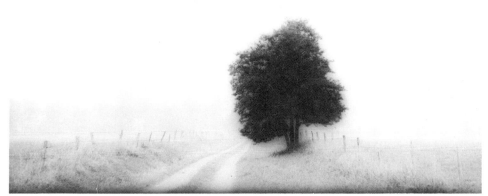

CADES COVE, GREAT SMOKY MOUNTAINS, TENNESSEE

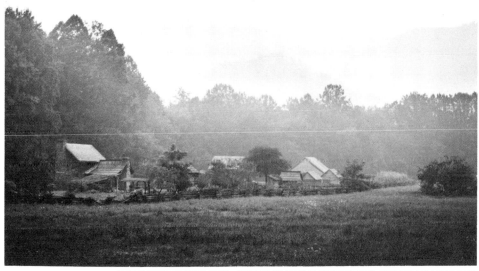

SETTLERS' COTTAGES, GREAT SMOKY MOUNTAINS, NORTH CAROLINA

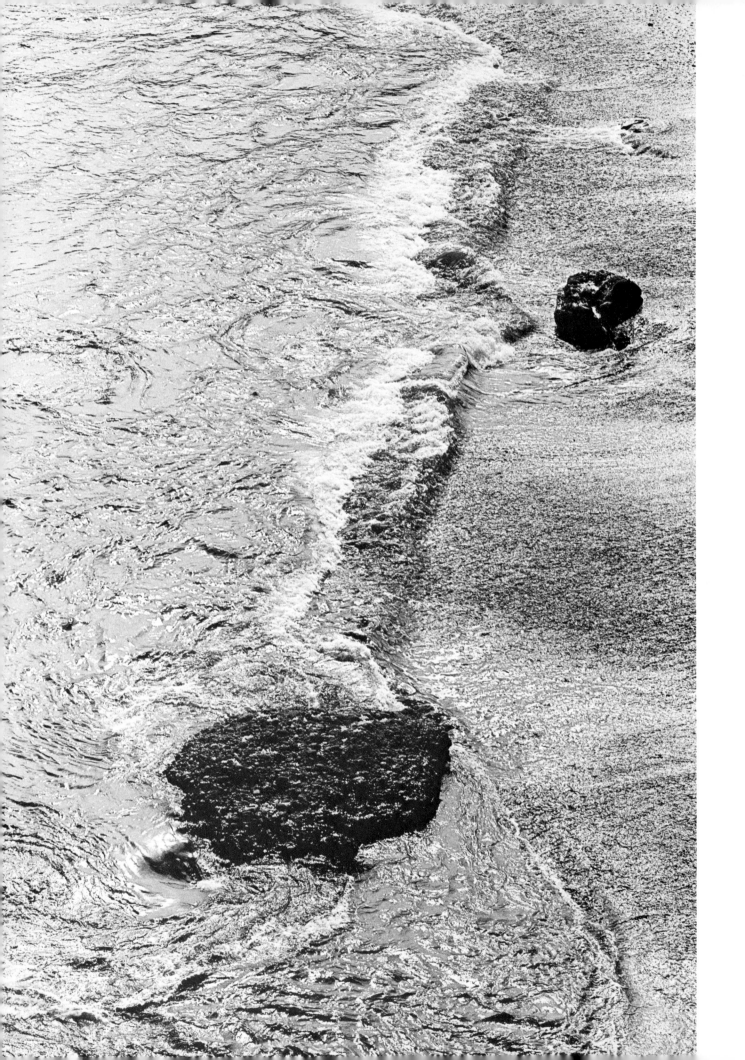

*S*ometimes the light in a scene is completely
unexpected. All of a sudden it's there in front of you,
seemingly by accident. So you react to the light
spontaneously and photograph it, and only later do
you figure out what it was that made the light so
appealing.

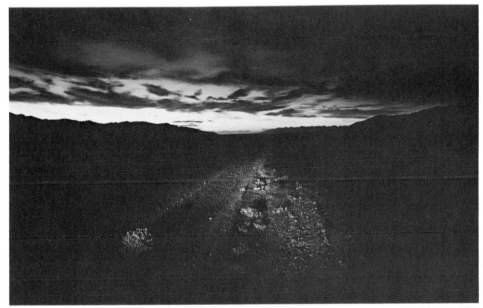

DUSK, DEATH VALLEY

*This unorthodox photograph derives its
impact from the unexpected presence and
shape of the circle of light illuminating the
roadway.*
*Without help from a car's headlamps, the
light from the horizon would not have been
sufficient to illuminate the foreground. At
the time the photograph was taken, the
brightness of the sky had diminished to the
point where both it and the foreground
light could simultaneously be "held" by
the film.*

ROCKS AND WAVES, POINT LOBOS

*This photograph of Point Lobos,
California, owes its "feel" entirely to the
nature and quality of the light as it struck
the water when the photograph was taken.*

*A low sun glancing off the surface of
the water gives the scene a sharp, etched
appearance that would not have been
present at another time of day or under a
different kind of light. This is an example of
a scene that pleads to be shot on
black-and-white film; on color film, the
scene would have lost its glistening, silvery
patina.*

*Nothing exceptional was done here in
taking this photograph save to react to the
effect of the light on the water and to
choose the correct exposure.*

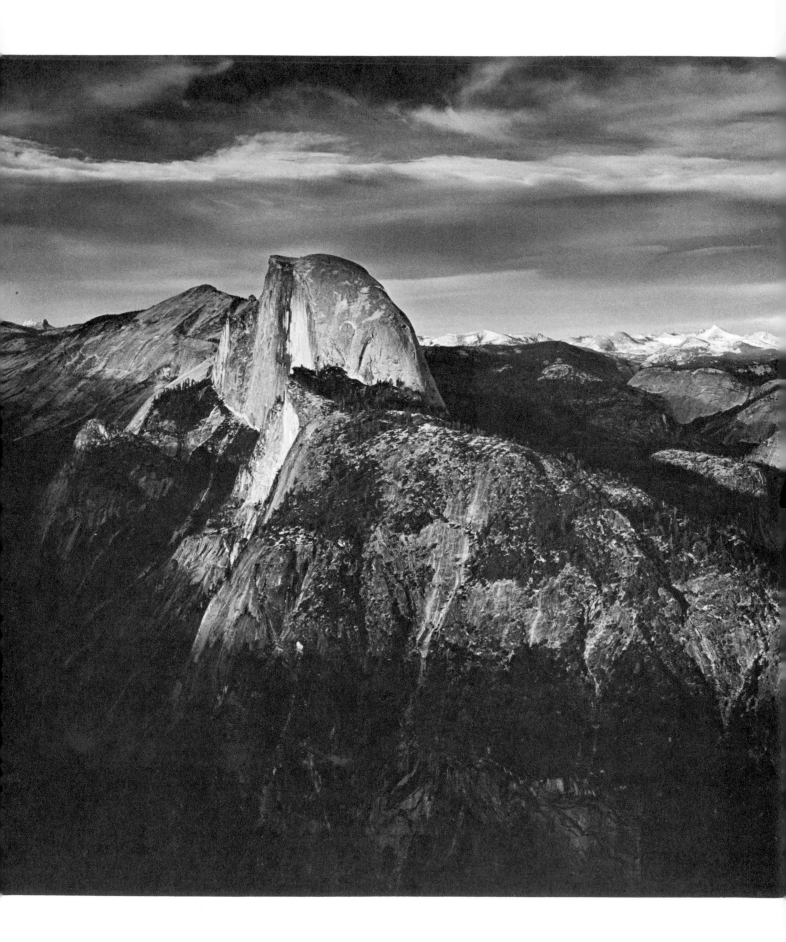

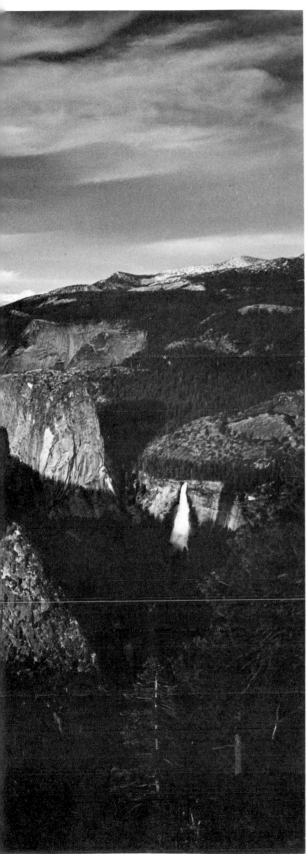

At sunset there is a sense of exhilaration that comes from never quite knowing exactly what's going to happen. You have very little time to act. I derive a great deal of satisfaction from stalking such an elusive subject and from going away knowing that I got it.

LAST LIGHT ON HALF DOME, FROM GLACIER POINT

When the sun starts to peek above the horizon on a clear day, sometimes those first rays flash across a scene so brilliantly that the effect reminds me of a studio strobe.

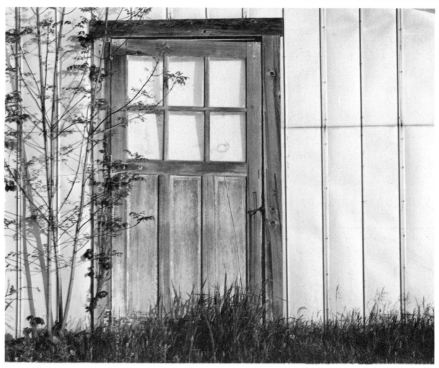

BARN DOOR, MORNING LIGHT

Early morning has a stillness and crispness not often found at any other time of day and that exists only briefly after sunrise.

The calm, cool feel of the lake scene at right results strictly from the special qualities of early morning light, which sharply defines the trees and sets them off clearly against a background still in shadow. Shortly after this photograph was taken, sunlight reached the background and a breeze roiled the water's surface, destroying the reflection.

At left, early morning frontlight on the door emphasizes its lines and produces an unusually clean pattern.

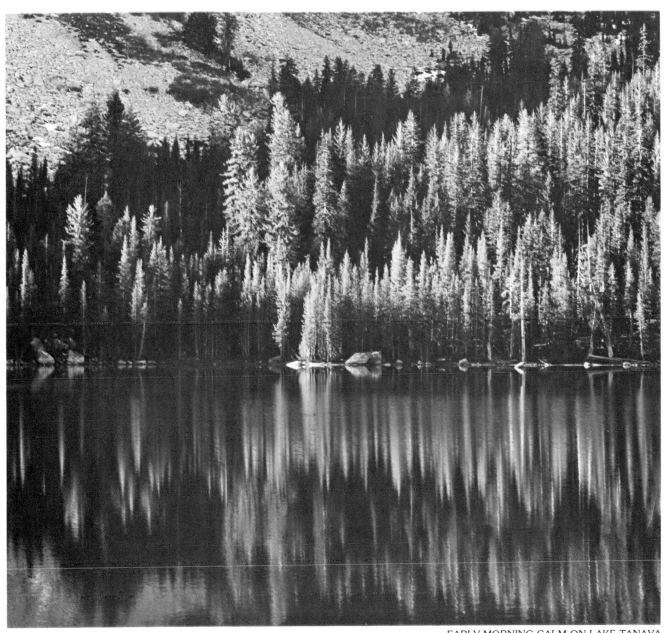

EARLY MORNING CALM ON LAKE TANAYA

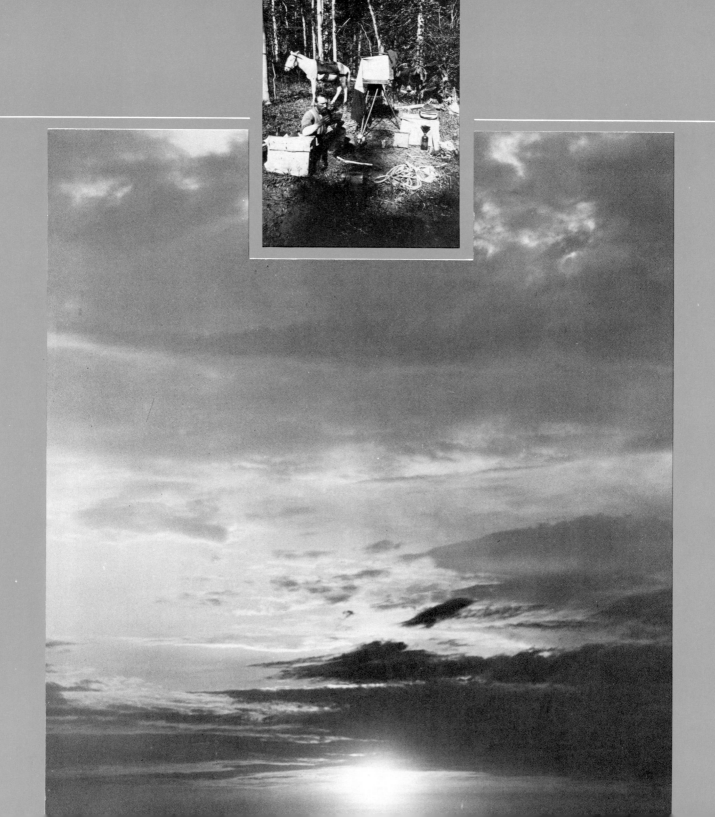

True artistry requires that a photographer be sensitive not only to his subject but also to the unique relationship that exists between his subject and the particular camera, lens, and light-sensitive materials he has chosen to use.

2. EQUIPMENT

To a greater extent than many other pursuits, photography requires a great deal of equipment, much of which is indispensable and expensive. However, no photographer needs to own every item of equipment available on the market, so there is an advantage to be gained from careful planning and the exercise of common sense.

The prerequisite to making intelligent equipment choices is that a photographer decide exactly what his goals are. A person for whom photography is primarily an adjunct to a love of hiking or backpacking will have significantly different needs from the person for whom hiking or backpacking merely provides the means for acquiring beautiful photographs.

The answers to a few pertinent questions will usually steer a person in the right direction. He should ask himself, "What is my primary purpose for taking photographs? Do I want to express myself artistically, or am I primarily interested in keeping a record of my back country travels? Am I willing to carry the extra weight that serious photography entails, or do I prefer to travel as light as I can? Or is my level of commitment somewhere in between?"

Equipment decisions should not be made casually. Because the bulk and weight of the photographic equipment a person transports affects the quantity of other items he can carry, equipment selection will determine, to an extent, his access to nature. For instance, carrying a full complement of view-camera gear limits the amount of food a person can pack, and trails that necessitate some rock climbing may be impossible to follow unless camera equipment is kept to a bare minimum.

The quality of photographic equipment a person purchases, too, has practical, aesthetic, and financial implications. From a practical standpoint, scenic photography usually takes the photographer far from any repair shop, and so dependability is a primary concern. Dependability costs money—but it is money well spent. Aesthetically, image quality is directly related to lens quality. Most photographers feel they save money more prudently by sacrificing unnecessary convenience features on the camera body than by buying cheap lenses. Especially in low-contrast conditions, lens quality affects the final image noticeably.

For the photographer on a limited budget, the best strategy is usually to invest money in high-quality used equipment rather than in low-quality new equipment. If he eventually decides to "trade up" to new equipment, he will find that good used equipment maintains its economic value very well, and his photographs will be better for having been taken with the best equipment he could afford. ☐

Inset: Single frame from a stereograph showing 19th century photographer Jack Hillers in his wilderness camp. The equipment is typical of that which wet collodion photographers routinely carried.

CAMERA FORMAT SIZES

The size of the film a camera holds—also known as its *format*—strongly influences the nature and quality of the final image. Traditionally, scenic photography has been associated with cameras that hold large individual sheets of film. Smaller format cameras that take roll-film, however, are perfectly capable of producing excellent scenic images when used properly.

Format has its main impact on the capability of a negative to withstand enlargement. As an image is enlarged more and more, the underlying structure of the film—its "grain" pattern—becomes increasingly noticeable in a print. Enlarging a 4" × 5" (10 × 13 cm) negative to a 16" × 20" (41 × 51 cm) print means that the image is increased 16 times in size. Enlarging a 35mm negative to the same size means an increase of 240 times. At such high magnifications, no matter how fine-grained the original, the enlargement will show signs of granularity. Thus, the extent to which a photographer expects to enlarge an image will affect the choice of camera format to at least some extent. As a general rule, a 35mm negative can safely be enlarged to 5" × 7" (13 × 18 cm) without incurring noticeable image deterioration.

The shape of the image produced by a camera is almost as important as the size of the negative. Printing papers are sold in standard dimensions given in inches: 5" × 7", 8" × 10", 16" × 20", etc. European papers have a few other standard sizes, but the principle is the same. If the film image does not conform exactly to the proportions of the printing paper, the image must be enlarged an additional amount in order to cover the entire surface of the paper or the paper trimmed down to match the shape of the frame.

The small-format 35mm image is too narrow for standard printing papers, but among medium-format cameras, the conditions vary. Some cameras are designed in an "ideal" format—for example, 1¾" × 2¼" (4.5 × 6 cm) or 2¼" × 2¾" (6 × 7 cm)—which conforms closely to standard paper sizes. In choosing a medium-format camera, a photographer must select the frame shape carefully. With any shape other than one of the "ideal" shapes, the image will not fit the standard paper sizes exactly. □

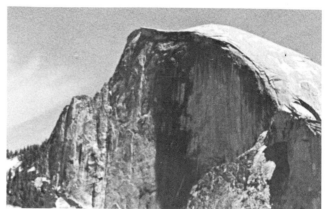

Section of a 16" × 20" print made from a 35mm negative

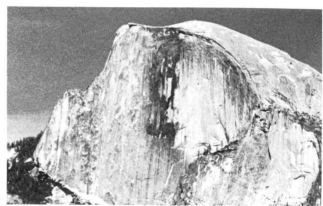

Section of a 16" × 20" print made from a 2¼-square negative

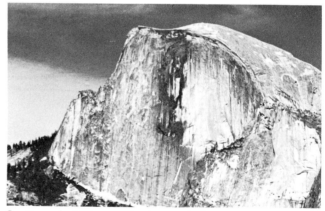

Section of a 16" × 20" print made from a 4" × 5" negative

The more a negative is enlarged, the more readily apparent grain becomes in the final print.

All three of the above photographs are sections of 16" × 20" prints. The top photograph represents a 35mm negative enlarged 240 times, the middle photograph a 2¼" (6 cm) square negative enlarged 64 times, and the bottom photograph a 4" × 5" negative enlarged 16 times. The differences in grain pattern are most apparent in the sky.

As illustrated by the photographs at right, a 35mm negative can be enlarged to 5" × 7" without the grain structure becoming especially apparent.

APPROXIMATE IMAGE ENLARGEMENT FACTORS
(Negative enlarged onto standard printing papers)

FILM FORMAT	PAPER SIZE 8" × 10" (20 × 25 cm)	11" × 14" (28 × 36 cm)	16" × 20" (41 × 51 cm)
35 mm	60	120	240
6 × 4.5 cm	20	40	80
2¼"–square	16	32	64
6 × 7 cm	13	26	52
4" × 5"	4	8	16

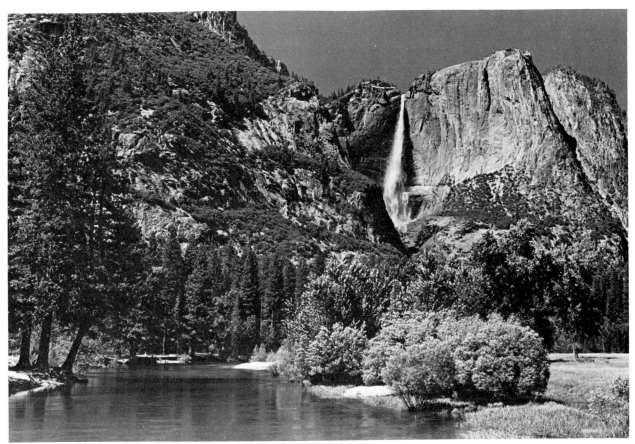

5″ × 7″ print made from a 35mm negative

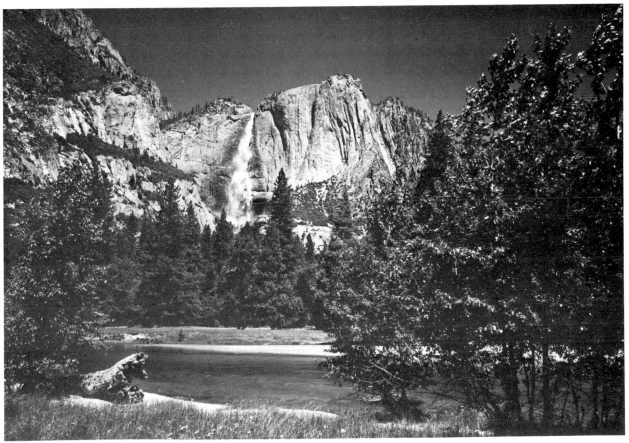

5″ × 7″ made from a 4″ × 5″ negative

MEDIUM-FORMAT CAMERAS

Medium-format cameras, those that use film sizes in between 35mm cameras and view cameras, combine some of the advantages of small-format photography with the increased image sharpness possible when prints are made from a larger negative size. At first glance, because of their comparative bulk, medium-format cameras might seem ill-suited to scenic photography, but in serious scenic photography, medium-format cameras do have their place.

Except for their shape, medium-format cameras are very similar to 35mm cameras. Most offer through-the-lens viewing and a variety of different lens focal lengths which are analogous to those available for 35mm cameras.

A valuable feature many medium-format cameras have is the capacity to accept different film backs. Merely by switching from one camera back to another, the film can be changed. Frequently a photographer finds it necessary to alternate from one film speed to another or to change back and forth between black-and-white and color films. Interchangeable film backs eliminate the need to carry more than one camera body or to rewind a partially exposed roll in order to change from one roll to another.

Medium-format cameras use a rectangular frame that either maximizes the number of exposures that can be fitted onto a standard roll of film (6 × 4.5 cm), or is proportioned to fit standard papers (6 × 7 cm).

The main problem is that for most photographs taken with a medium-format camera, the image produced by a 35mm camera would have been perfectly satisfactory. Since a medium-format system that is comparable to a 35mm system weighs at least twice as much, carrying the extra weight often does not seem worthwhile.

One compromise is to carry a medium-format rangefinder camera with a fixed (i.e., nonremovable) lens to use in those instances when a larger negative is absolutely crucial. Even in combination with a 35mm body and lenses, the total weight is substantially less than a comparable medium-format system alone, and the combination incorporates some of the best features of both systems. Of course, the inability to change to another lens is limiting, but if the fixed lens is slightly wide-angle, chances are it will be adequate in most situations. □

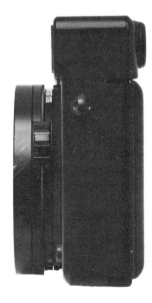

Lens collapsed

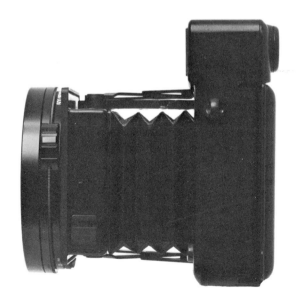

Lens opened

Plaubel Makina 67

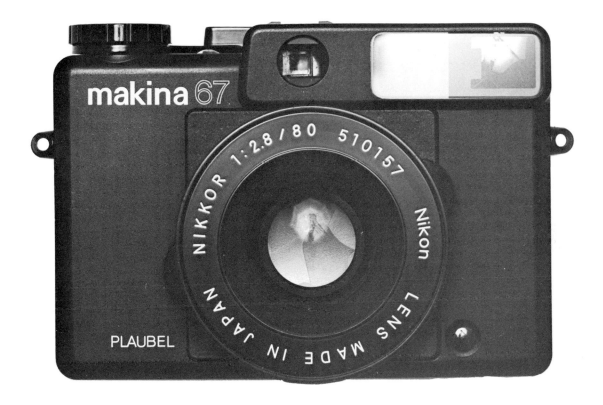

The Makina 67, manufactured by Plaubel, affords the photographer who does not have much space or cannot afford to carry much weight a convenient means for maintaining the ability to produce 6 × 7 cm (2¼" × 2¾") negatives.

The Makina is fitted with a fixed 80mm high-quality Nikkor lens (which is approximately equivalent to a 35mm lens on a 35mm camera), a built-in light meter, and an exceptionally accurate rangefinder. The camera weighs only slightly more than a 35mm SLR, and in its collapsed configuration (previous page, upper right), measures only 6.5" × 4.5" × 2.25" (16.5 × 11.4 × 5.7 cm).

Its unique features mean that the Makina offers 35mm photographers a reasonable method for generating a medium-format negative without the need to carry an elaborate second-camera system.

MAXIMIZING IMAGE SHARPNESS

Extreme sharpness is a quality shared by many of the most famous scenic photographs ever taken. To a great extent, this sharpness results from the capabilities of large negatives to produce prints containing exquisite detail, but it also results from some of the specialized techniques large-format photographers routinely employ. A close examination of many of the outstanding examples of traditional scenic photography reveals two common characteristics: the depth of field is almost always extremely extensive, and the foreground elements appear in sharp focus. By using techniques that produce these characteristics, even a photographer shooting 35mm film can produce images with that traditional "scenic" feel.

Two fundamentals of producing sharp images with small-format cameras—using fine-grain film and using a tripod—have already been mentioned. The smaller the lens aperature used, the more extensive the depth of field produced. Using a tripod permits a photographer to accommodate the extremely slow shutter speeds that these small lens apertures require, and also prevents camera shake from reducing image sharpness. In addition, lens choice and point of focus make important contributions to image sharpness.

Lens choice. The depth of field produced by a lens relates directly to the lens's focal length. The shorter the focal length, the greater the depth of field (at a particular lens aperture). Although there are many uses in scenic photography for both telephoto and normal lenses, wide-angle lenses are without doubt the most useful of all. Not only do they produce sharp images over a broad range of distances, wide-angle lenses also distort perspective in a way that lends a feeling of expansiveness to a scene.

Hyperfocal distance. In order to extract every last bit of sharpness from a lens, the entire extent of the lens's depth of field must be utilized. However, when a lens is set at "infinity," some of that depth of field is "wasted." This waste occurs because a lens's depth of field extends on both sides of the point at which the lens is focused. Since the "infinity" setting represents a point a finite distance away (30 meters or 98.4 feet, for example) and since everything beyond that point will automatically appear in focus anyway, when the lens is set at "infinity" the depth of field will actually affect only those portions of the scene *nearer* to the camera than that particular lens's "infinity" distance.

To utilize the entire depth of field effectively, the camera should be focused *closer* than the "infinity" distance, at a point called the *hyperfocal distance*. How much closer depends on the lens and the aperture being used. Most modern lenses incorporate pairs of depth-of-field indicator lines on the lens. These lines are usually color coded to correspond to the lens's aperture settings. If, instead of focusing the lens on "infinity," the point of focus is offset just enough so that one of the depth-of-field indicator lines is aligned with the "infinity" marker, the depth of field will still encompass objects at "infinity" and beyond but will now extend much closer to the camera than was the case when the lens was focused on "infinity." □

Hyperfocal distance

At each of its apertures, a lens can be set to its hyperfocal distance, which is the focusing point that yields the broadest possible depth of field. The most extensive depth of field of all occurs at the hyperfocal distance of the lens's smallest aperture.

Most lenses have depth-of-field marker lines engraved on the aperture ring. For each aperture, two lines (one on either side of the central focusing line) indicate how far in front of and behind the point of focus the depth of field extends. The uppermost of the two lenses shown below is set to f/16 and focused on "infinity," and the depth of field extends from "infinity" down to about seven feet (two meters).

The point of focus of the lower lens has been offset to the hyperfocal distance. This was accomplished by rotating the focusing ring counterclockwise until the depth-of-field marker line was located where the central focusing line previously stood. (On some lenses the direction to rotate the focusing ring will be clockwise.)

The two photographs at the bottom of the next page illustrate the effect on depth of field of changing from the "infinity" setting (left photo) to the hyperfocal distance (right photo).

Lens focused at "infinity"

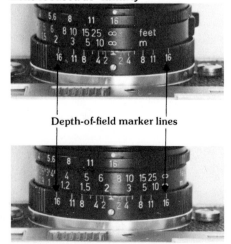

Depth-of-field marker lines

Lens focused at hyperfocal distance

Selective focus

In the near photograph, at right, an overcast sky produced a dull background that did not deserve the emphasis that sharp focus affords. Moreover, since the gray tones in the tree and the background rock were similar, the danger existed that the end of the rock might seem to blend into the tree branch. Selectively opening the lens to its widest aperture threw the background out of focus.

At far right, the presence of a clear sky and sunlight significantly altered the scene. The background and sky were more interesting, and a highlight on the branch separated it from the background rock. Selectively focusing on the tree was no longer necessary, so depth of field was maximized by focusing a smaller aperture at its hyperfocal distance.

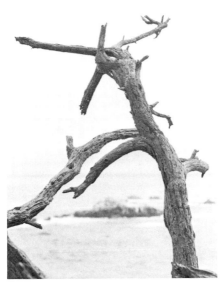 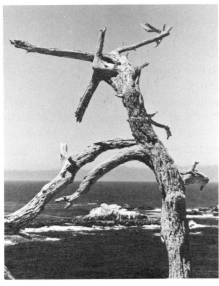

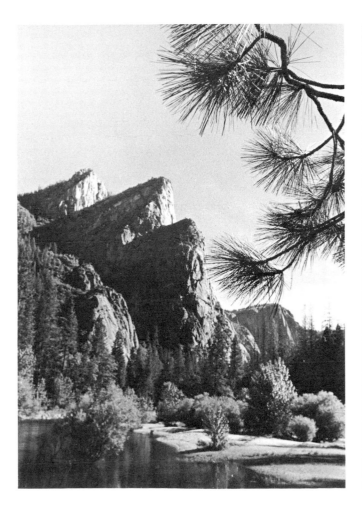 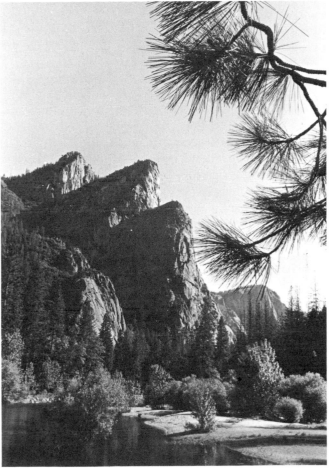

VIEW CAMERAS

In its simplest form, a camera is no more than a light-tight box in which film is placed to be exposed, at some later time, to a controlled amount of light. Mirrors, prisms, high-speed shutters, built-in light meters, and all the other paraphernalia commonly associated with photography, while admittedly very useful, in many ways are primarily conveniences. Although modern view cameras incorporate sophisticated technological refinements, a view camera essentially consists of nothing more than a box with a lens on one end linked by a compressible bellows to a device that holds a sheet of film on the other.

What sets view cameras apart (aside from the size of the film they use) is their capacity for independently changing the relative orientations of lens and film. This unique capability permits a degree of focus and perspective control impossible with any other type of camera. By raising, lowering, swinging, or tilting either the lens or the film or both, simultaneously and independently, a photographer can easily manipulate the image striking the film.

The full capabilities of the view camera are most valuable in a studio setting, but some of the controls—especially front tilts and swings—are also useful in outdoor photography. However, the view camera does present some problems to the photographer who must continuously move about from place to place.

One problem is the camera's weight and bulk. A 4" × 5" camera is much heavier than a small- or medium-format camera, and the situation is even more extreme with an 8" × 10" camera. "Field" cameras, which are much more compact than studio versions, are far easier to carry but usually do not permit equally extreme camera movements.

Another problem is the amount of time necessary to set up a view camera. Whereas small- and medium-format cameras can be used quickly and easily, a view camera must first be unpacked, set on a tripod, and leveled. Then, any needed adjustments must be made, the film must be inserted, and time must be spent waiting for camera shake to cease. After the shutter is released, most of the process must be repeated in preparation for a second exposure. In an equivalent amount of time, ten or more frames could easily have been exposed on a small- or medium-format camera. As a result, photographs taken on a view camera lack the feeling of spontaneity that often characterizes photographs taken with smaller cameras. Equally important, view cameras frequently are not versatile enough to respond effectively to rapidly changing conditions, such as the changes in the quality of light that occur at dawn and dusk.

Without question, view cameras offer a photographer capabilities unmatched by other camera formats, but these are capabilities that require patience and a meticulous approach that many photographers do not wish to exercise. To practice view camera photography, a photographer must be willing to tote heavy, bulky equipment long distances and to miss an occasional fleeting image for the rewards of being able to work from large negatives. Not every photographer needs to, or should, work with a view camera, but those who do practice a very special form of photography. □

Camera collapsed

The Toyo 45A Field Camera is a typical example of a large-format camera specifically designed to be easily transportable.

Compared to the less-mobile studio view camera, a field camera is smaller, lighter, and folds up compactly. (A studio view camera is used to illustrate camera movements on page 40). The smaller size of the field camera, while saving weight and space, requires that some sacrifices be made: the camera movements possible with a field camera are somewhat restricted. These limitations prevent a field camera bellows from extending far enough to provide extreme close-ups. Moreover, some camera movements are more awkward to execute with a field camera than with a studio camera.

Above, the 45A, which produces a 4" × 5" negative, is shown folded up. (Before being collapsed, the camera's lens must be removed.) At right, the camera is shown in its fully open configuration, with a lens mounted in the front standard.

Toyo 45A Field Camera

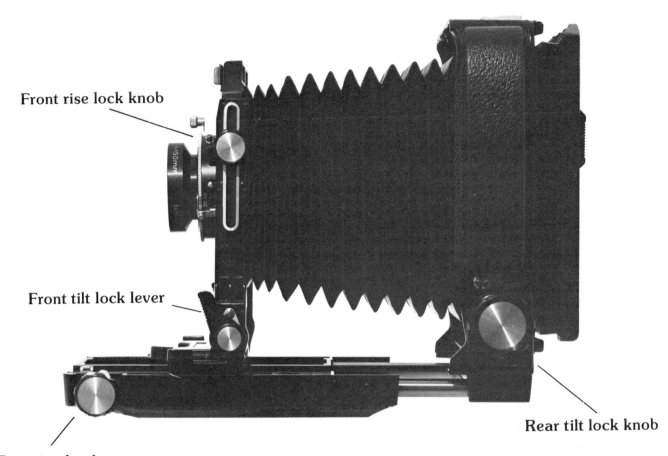

Front rise lock knob

Front tilt lock lever

Focusing knob

Rear tilt lock knob

ACCESSORIES

Tripod. Outdoor conditions can be harsh. A tripod may be subjected to sand, rain, mud, and saltwater. The surfaces on which the tripod is set may be slippery. A strong wind may buffet the camera sitting atop the tripod. For all of these reasons, the highest quality tripods are well worth the additional money.

In selecting a tripod, a photographer should seek one with firm twist grips (twist grips are more reliable than latches) to secure the leg extensions. Tripods with a ball-and-socket arrangement to secure the mounting platform in place are easier to use and more compact to transport than the type that uses two separate handles. The heavier the camera to be supported, the heavier the tripod should be.

Light meter. Aside from being convenient to use for taking close-up readings of individual elements in a scene, a hand-held light meter provides a backup in case a camera's built-in meter fails. Moreover, a hand-held meter that can take incident light readings greatly simplifies the process of making exposure calculations under extreme lighting conditions. Spot meters, which take light readings from a very restricted area, are useful for determining when the light values of individual elements in a photograph exceed the recording capacity of the film (see Section 4).

Changing bag. A light-tight changing bag provides an emergency "darkroom" should film become jammed in a camera while in the field. For view cameras, a changing bag permits the photographer to carry only a few film holders, which can be reloaded as needed.

Lens shades. Direct sunlight striking the surface of a lens produces lens "flare" and seriously reduces image contrast. To help minimize flare, every lens should be fitted with a lens shade designed specifically for that lens.

Plastic bags. To protect equipment from inclement weather, overturned canoes, excess humidity, etc., plastic bags are indispensable. A variety should be carried, ranging in size from large enough to line a backpack to small enough to carry a few rolls of film. Some of the bags should be of the sealable, airtight variety.

Backpack. The specific pack to use for carrying camera equipment will depend upon the amount of non-camera equipment to be carried. In general, however, hikes of any appreciable duration, especially if the terrain is rugged, require some special arrangement for camera equipment. A standard shoulder-slung camera bag is uncomfortable, awkward, and dangerous for use in the back country, especially if any climbing becomes necessary. For light traveling with a compact camera system, a waist pack is often sufficient. But to carry more equipment or for longer treks, a regular backpack may be essential. Some manufacturers sell packs specifically designed to carry camera equipment within easy reach.

Screwdrivers. There seems to be a rule in nature that the farther a photographer is from a repair shop, the more likely his equipment is to fall apart. A small set of high-quality jeweler's screwdrivers is an inexpensive form of "insurance."

Spare batteries. Modern cameras and light meters depend on electricity. A fresh replacement for each and every battery is vital. □

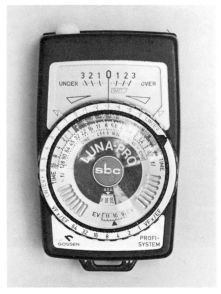

Hand-held light meter

Most serious photographers consider a hand-held light meter to be indispensable. Hand-held meters are more accurate than meters built into a camera, and more convenient to use for taking close-up light measurements. As a result, even photographers whose cameras contain built-in meters often carry one of the hand-held type, also.

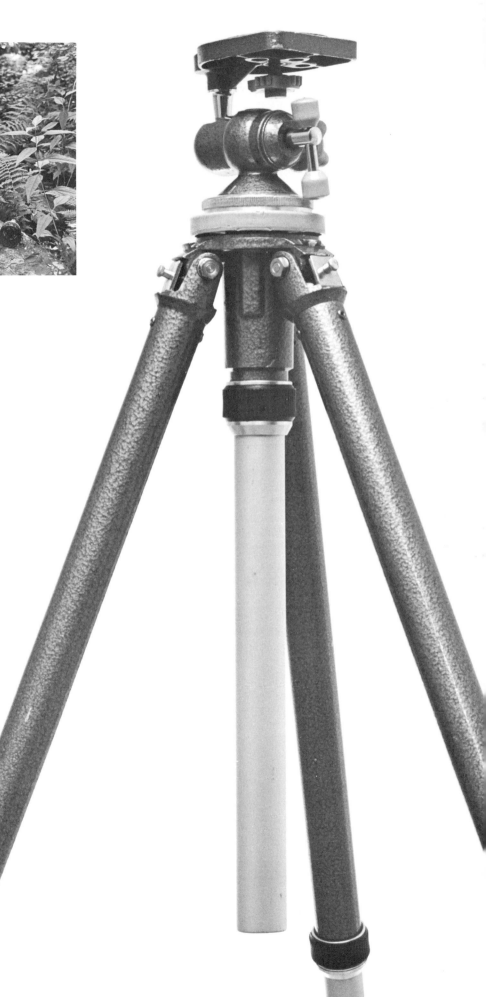

Photographic backpack

Several manufacturers of outdoor equipment sell rucksacks and backpacks specifically designed to accommodate photographic equipment.

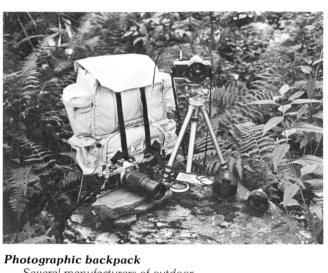

The pack shown above features many individual, heavily-padded pockets, both within the pack and on the outside. Aside from providing protection, the pockets simplify locating individual items of equipment.

The padding takes up so much space that most of these packs do not provide much room for food and clothing, but are excellent for use on day trips into the backcountry.

Tripod

A sturdy, dependable tripod is absolutely essential to the serious scenic photographer. The Gitzo brand tripod shown here is one of the most suitable for rugged—even abusive—use. It is heavier and more expensive than many other tripods, but is unsurpassed at steadying a camera, even on rough terrain and in a wind. One of its nicest features is a mounting head with firm, easy-to-use controls. The heads are expensive, but can be detached and used on any Gitzo base. This feature makes it possible for a photographer to own bases of different weights for use with different cameras.

LENS FOCAL LENGTHS

In order for one of the most obvious features of modern camera systems—the easy interchangeability of lens focal lengths—to be exploited to greatest effect, a photographer must be completely familiar with the differences in image perspective produced by different lenses.

The visual effect generated by a particular focal length is a product of the size of the film in the camera. When the focal length of the lens approximately equals the diagonal of the film frame, objects within the frame are rendered in "normal" perspective. That is, the difference in size between near objects and far objects appears to conform more or less to the size differences people are accustomed to observing with the unaided eye.

Both telephoto and wide-angle lenses distort these size relationships. With a telephoto lens, an object located far from the camera does not appear as small as it normally would. Even if two objects that are the same size are located at greatly different distances from the camera, the farther object will appear uncommonly large relative to the other. This creates the illusion that distance has been compressed. Conversely, wide-angle lenses make objects seem farther apart than they really are. Objects in the foreground of a photograph appear to loom, whereas objects that are only slightly farther away seem disproportionately small by comparison.

The key consideration is choosing the lens that will produce the type and amount of perspective control that the photographer desires. Indeed, one mark of a skilled scenic photographer is his ability to manipulate, through appropriate lens selection, the size relationships of the objects in a scene to support a concise visual message.

To the greatest extent possible, lens choice should be a matter of creative intent. No one lens is automatically the best in any situation, but one particular lens is always best as a means for achieving a particular visual effect. If practical considerations, such as an inability to approach a subject closely, dictate lens choice, the resulting photograph is more likely to merely document a scene than to interpret it.

Although any lens can be appropriate for taking scenic photographs, wide-angle lenses have found particular favor among scenic photographers. Most people think of nature as majestic and sweeping; because wide-angle lenses distort perspective in a manner that enhances the feeling of distance and space between objects, many photographers automatically reach for their wide-angle lenses more frequently than any other. A danger exists, however, that a photographer might begin to visualize scenes only in terms of a wide-angle viewpoint. While a sign of a good photographer is the presence of a recognizable style, prudent photographers try to visualize every scene as it might look through a variety of different focal lengths. This practice helps prevent a photographer from becoming complacent. If two different photographers looking at the same scene can see it in different ways, there is no reason why a single photographer cannot train himself to seek out alternative interpretations. All of a photographer's photographs will be better for his having made the attempt. □

Relationship Between Angle of View and Various Combinations of Lens and Format.

HORIZONTAL ANGLE OF VIEW (DEGREES)	Focal Length (mm)				
	35mm FORMAT	2¼-SQUARE FORMAT	6 × 7 cm FORMAT	4 × 5 in. FORMAT	8 × 10 in. FORMAT
110°	16mm	24.5mm	31mm	53mm	106mm
92	21	32	40	70	140
84	24	37	46	80	160
76	28	43	54	93	186
64	35	54	68	117	234
46	50	76	96	167	334
44	55	84	105	183	366
27	90	137.5	172.5	300	600
23	105	160	201	350	700
18	135	206	259	400	900
12	200	306	383	667	1334
8	300	458	675	1000	2000
6	400	611	766	1333	2666
3	800	1222	1533	2667	5334

20mm

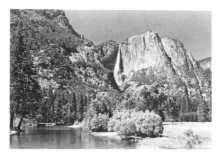

35mm

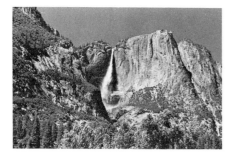

55mm

105mm

200mm

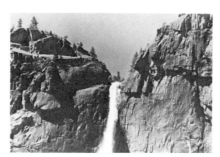

400mm

The angle of view taken in by a lens depends on the relationship between the size of the film (its format) and the lens's focal length. Doubling the focal length of the lens being used cuts the angle of view in half.

The photographs at left illustrate the effect produced by a variety of common focal lengths on a 35mm camera's angle of view.

A given focal length will produce a different angle of view on different formats. For each of five common formats, the chart on the previous page indicates which lens should be used to achieve a certain angle of view. The chart is most useful in determining the equivalent lens to use when switching from one format to another. For example, according to the chart, a 50mm lens on a 35mm camera is equivalent to a 76mm lens on a 2¼"-square camera.

ENLARGERS

Because even the best commercial lab can do no more than follow instructions, there is no substitute for a photographer doing his own printing. If a photographer expects to exercise control over the "complete" photograph, he must be present to make creative and technical decisions as the print is being made. Equally important, in order for a comprehensive system of contrast control (like the one described in Section 4) to be effective, it should be calibrated on a particular enlarger.

Various considerations enter into the decision over which enlarger to buy, but none is more important than overall quality. Since a print is no better than the weakest link in the optical chain that produced it, the best negative in the world is of little value if it is printed on an inferior enlarger. To derive full value from expensive camera equipment, a serious photograper should work with the very best enlarger/lens combination he can afford.

Poor quality equipment can significantly affect a print. If the plane in which the film is held is not precisely parallel to the plane of the printing paper, distortion occurs and edge-to-edge focusing can be impossible. If the column on which the enlarger head is mounted is weak, vibrations will cause motion blur, especially when the head is raised high above the paper. If the lens is inferior, the image may not be as sharp on the edges as in the center.

Purchasing high-quality darkroom equipment is more a one-time investment than is true with camera equipment. In general, a good enlarger will not become outdated, and usually will need only to have a few components eventually upgraded. And since only a few companies manufacture enlargers, comparison shopping is not nearly as difficult as with camera equipment.

There are two main categories of enlargers: condenser and diffusion. A condenser enlarger uses lenses to focus light from the enlarger bulb directly onto the film. Diffusion enlargers first gather light from the bulb and then bounce the light around within a special chamber before allowing the light to fall on the negative or slide. (See diagrams at right.)

A print made on a condenser enlarger appears different from a print made on a diffusion enlarger. Condenser enlargers produce a sharper image with more contrast (fewer distinct shades of gray). Diffusion enlargers generate a softer and less distinct image that displays diminished contrast (subtler shades of gray).

"Dichroic" heads make diffusion enlargers particularly well-suited to color photography. A dichroic head contains special color filters that can be introduced into the light path by turning dials to adjust color balance. The same process with a condenser enlarger requires that individual filters be manually inserted in a filter drawer. Although photographers who work mostly with black-and-white film tend to prefer the sharper images and higher contrast produced by condenser enlargers, diffusion enlargers have a special advantage in black-and-white printing: the ability to dial in filtration makes working with variable-contrast printing papers very easy. □

Used by most professional and serious amateur photographers, the Omega 4" × 5" enlarger shown at right produces extremely high-quality images. Even small- and medium-format negatives print better on this enlarger than on smaller enlargers.

The size and weight of a 4" × 5" enlarger contributes substantially to image quality. Large surfaces are easier to align and keep aligned than small surfaces, so the negative and paper are always maintained parallel to each other. The comparatively heavy weight of the 4" × 5" head reduces the effect of miscellaneous vibrations, and the thick column on which the head is mounted contributes additional stability.

The model shown has an optional feature that simplifies printing from different negative sizes: three lenses, one each for small-, medium-and large-format films, are mounted on a turret that can be easily rotated to switch from one lens to another. The timer shown has the capability of timing exposures to the nearest 1/10 sec.

Any photographer who is serious about darkroom processing and can afford the high purchase price should consider outfitting his darkroom with a large-format enlarger.

The Condenser Enlarger

Diffusion Enlarger

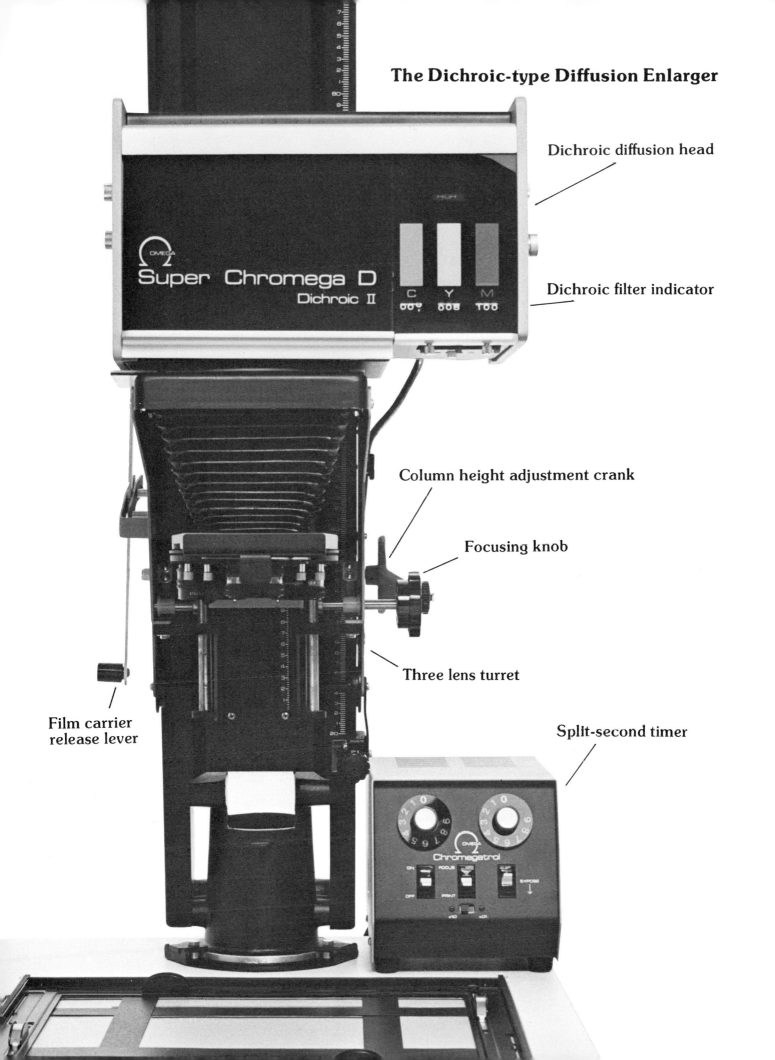

The Dichroic-type Diffusion Enlarger

Dichroic diffusion head

Dichroic filter indicator

Column height adjustment crank

Focusing knob

Three lens turret

Film carrier release lever

Split-second timer

PORTFOLIO II

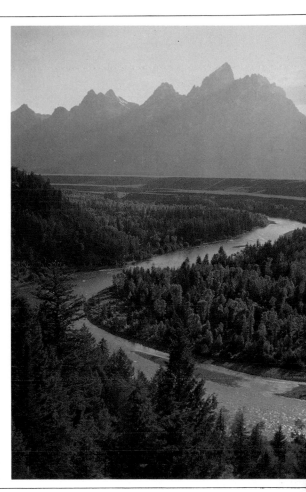

THE COLOR IMAGE

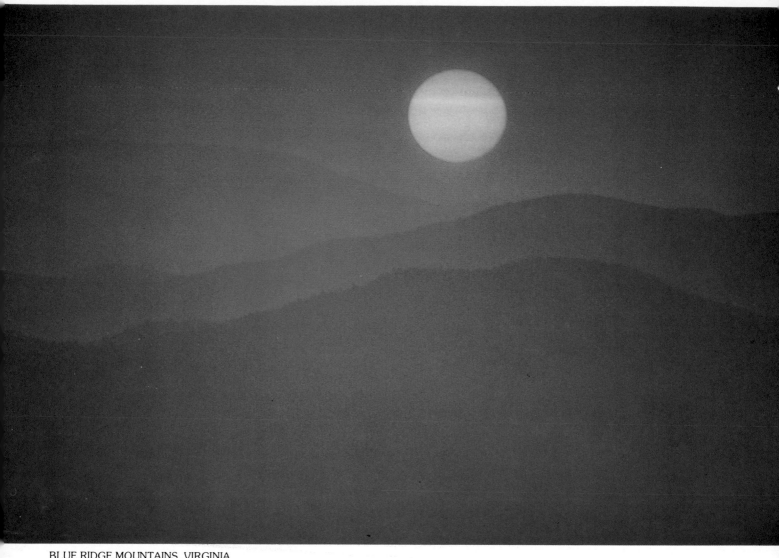

BLUE RIDGE MOUNTAINS, VIRGINIA

Switching from black-and-white to color is almost like switching to a different medium. You have to look at the world differently, you have to think differently, and you have to photograph differently.

Color can be deceptive. Sometimes the color in a scene is so strong that a photograph turns out to be nothing but color. Unless a photographer makes a conscious decision to make color itself the subject of the photograph, color is best employed in support of the photograph's actual subject.

These three photographs all use a monotone of color to tie the visual elements within the scene together. In each case, however, the monotone is punctuated by splash of contrasting color to provide visual interest.

In the photograph at left, atmospheric haze enveloping the Blue Ridge Mountains lends this photograph its dominant blue color. The contrasting orange of the sun` relieves the overall monotone effect.

At right, the monotone is created through the use of a magenta filter. Contrast is provided by the silhouette of the tree against the water.

Below, without the inclusion of the tiny white flowers, the green of the bed of sorrel—although rich and pleasing to the eye—would have been unrelenting and therefore dull. The flowers add just the right amount of visual interest.

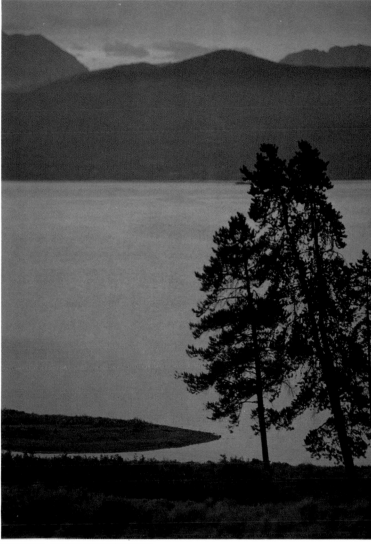

SUNRISE, ROCKY MOUNTAINS

SORREL, MUIR WOODS, CALIFORNIA

*M*y favorite light is a backlight. It may be difficult to meter, but I love its subtleties and the nuances of color it generates. Often, just the slightest shift in position or angle changes a backlit scene from the soft, even monotone produced by flare into the deeply saturated colors of a hard, direct light.

—— DUNE SUNRISE, DEATH VALLEY ——

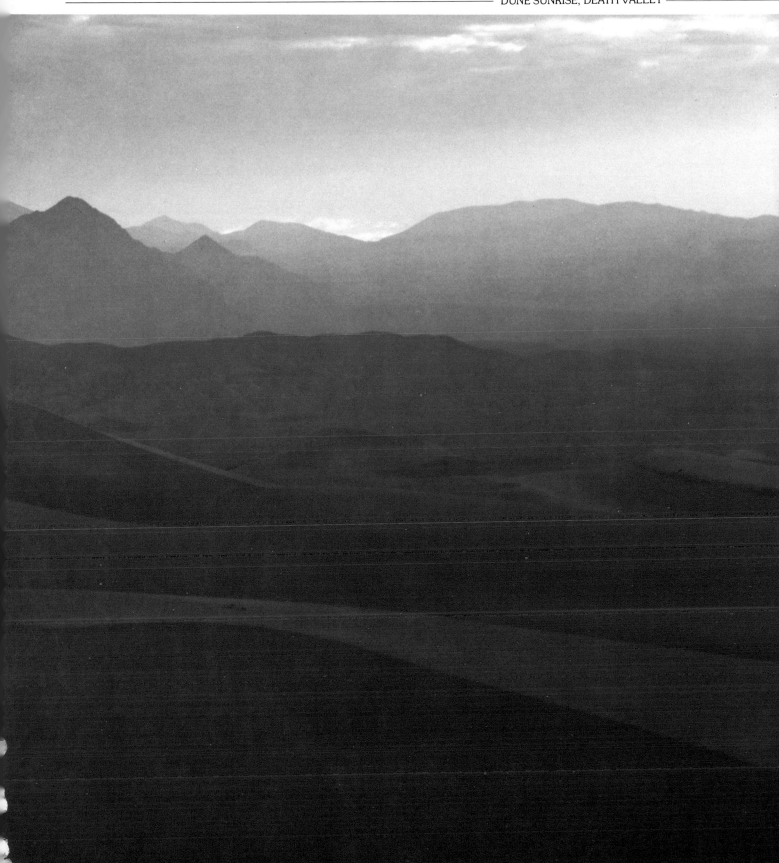

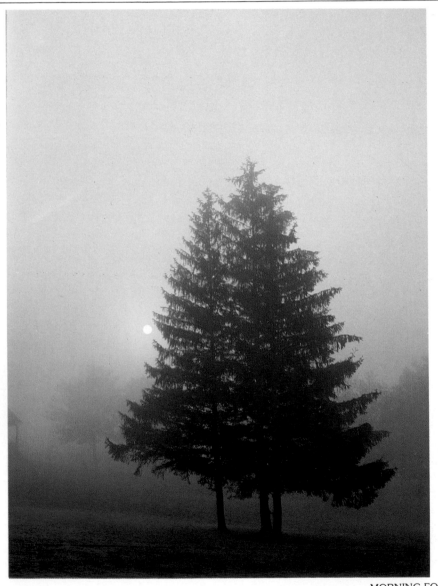

MORNING FOG

No color film can reproduce the colors in a scene exactly. Some colors are always rendered more accurately by a film than others, and each film behaves differently depending on the type of light that is present. So any responsibility a photographer feels to remain faithful to the colors actually present in a scene is a self-imposed obligation—and a goal that is nearly impossible to achieve.

At left, an amber filter muted the brilliance of the sun and added a feeling of warmth to the photograph that was not actually present in the original scene.

A *photographer really has much the same freedom*
that a painter enjoys to use colors for their
interpretive value.
I admire the approach of the Impressionists, who
rejoiced in perceiving—and enhancing—the subtle
colors present in a scene. The Impressionists used
palettes of paint; a photographer's palette consists of
his choice of film and filters, and his ability to exploit
variations in the natural colors of scenery and sunlight.

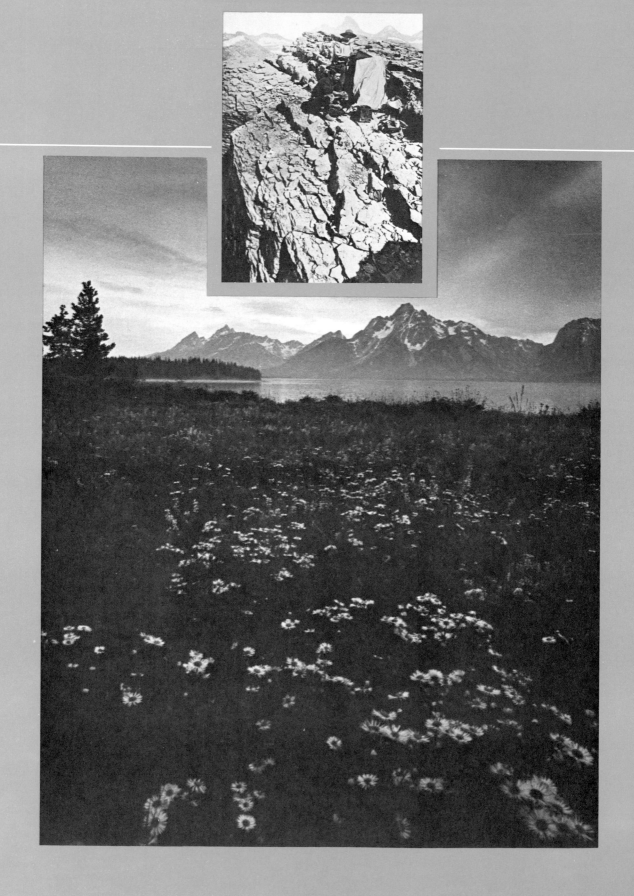

The creative heights to which a photographer can aspire are boundless, but his aspirations will inevitably be frustrated if he permits gaps to remain in his knowledge, or shortcomings in his skills.

3. TECHNIQUES

The intricacies of camera technology have resulted in serious photographers placing a substantial amount of emphasis on technical skill. Indeed, many photographers derive great satisfaction from their ability to extract with their equipment exactly the image that they want. Although skill alone is usually not sufficient in itself to "carry" an artistic photograph, the value to a photographer of having a broad reservoir of technical competence cannot be overstressed. For no matter how creative an imagination a photographer might have, if he lacks the technical skills necessary to convert his vision into a printed image, his talent will never be realized.

In creative photography, skill and vision are intertwined. The way a photographer visualizes a scene is greatly affected by his knowledge of the way his equipment can render the scene in a print. For example, by knowing how what a camera sees differs from what he sees with his eyes, a photographer can train himself to anticipate how particular combinations of technical elements will alter a scene in the course of producing the final image. This skill is the first and absolutely essential step in developing the ability to "previsualize" a photograph; that is, the ability to design the photograph in one's mind— before the camera shutter is released.

Because of the technical complexity of photography, a conscientious photographer must master a wide variety of individual techniques if he is to be able to handle any photographic challenge he faces. Since camera, lens, filters, exposure, and all the other technical aspects of photography produce images unlike those produced by any other medium, a photographer cannot learn to previsualize a scene until he has exposed himself to thousands upon thousands of images. Within the broad field of "scenic photography," some techniques are especially useful to know because they are encountered so frequently.

Some techniques, such as the ability to take close-up photographs, are necessary for handling unusual situations. Other techniques, such as the use of colored filters, are most useful for making the most of less than ideal conditions. The techniques described in this section fall into both categories.

The photographer who can combine these techniques with a strong creative vision will be well on his way to being able to produce excellent scenic photographs consistently, under any conditions. He will not use every technique in every photograph, but in almost every scene he will find one or more very valuable. □

Inset: William Henry Jackson and assistant perched on a rocky cliff (thought to be in the Grand Tetons), working with wet collodion equipment. The large photograph shows the Grand Teton Range as it is today, incorporated in one of the many national parks which ultimately were formed due to the influence of Jackson's photographs.

FILM

When the only cameras available produced relatively large negatives, film selection was not especially important. One film might have had different contrast characteristics from another, but, at least in terms of grain size, films were essentially interchangeable. Today, with the widespread use of small- and medium-format cameras, film choice has become critical, and a photographer who chooses film arbitrarily will not be using the capabilities of the medium to the fullest.

The most obvious choice to be made about film—whether to shoot in color or in black-and-white—precipitates additional decisions. If the initial choice is color, then the next choice is whether to produce prints or slides.

Slides vs. prints. Slide film has some substantial advantages over negative film. For reproduction in magazines or books, slides produce a better image than prints. In addition, whereas high-quality prints can be easily made from slides, the reverse is not true. And because color printing paper is costly in terms of both materials and labor, if a photographer expects to make only a few prints, he will find that shooting slide film and making only those prints he actually needs will be more economical.

On the other hand, prints made from slides exhibit greater contrast than prints made from negatives. Thus, if print quality is of prime importance, then negative film should be used.

Color bias. Color "bias" refers to the tendency of a particular film to exhibit an underlying hue of one color or another. Agfa films tend toward an amber hue, Fuji films toward green, Kodachrome film toward red, and Ektachrome film toward blue/green. If necessary, color bias can be corrected in the darkroom during the process of making prints or duplicating transparencies.

Color film quality. The primary consideration in measuring film quality is grain. The fineness of grain structure is an inherent characteristic of each film.

Without question, the finest-grained color film made is Kodachrome 25 slide film, which is available only in 35mm format. Even Kodachrome 64 demonstrates a larger grain structure. Therefore, if image sharpness is important and a 35mm camera is being used, Kodachrome 25 is the film of choice.

For larger formats, Kodak Ektachrome film, or similar films from other manufacturers must be used. Because the negative produced is relatively large, though, the grain structure is much less noticeable than with 35mm film. In general, the larger the format and the smaller the degree to which the ultimate image is to be enlarged, the "faster" the film can be without objectionable grain appearing in the final print. No color print film is as fine-grained as Kodachrome 25 slide film.

Black-and-white film quality. In black-and-white also, there is no film as fine-grained as Kodachrome 25. Moreover, comparatively little difference exists between the

slowest black-and-white films and intermediate-speed films. Therefore, in most situations, there is little to be gained by using the finest-grained films unless it is important to obtain every last degree of sharpness. In general, black-and-white photography uses medium- or even high-speed films routinely.

Image softness. Although scenic photographs in the last 60 years have been characterized by extreme image sharpness, some photographers prefer on occasion to produce "soft" images. In such circumstances, high-speed, grainy films are often desirable. □

Some Black-and-White Films

FILM TYPE	CHARACTERISTICS	FILM NAME	ISO
Slow	Fine grain; High-quality resolution	Agfapan 25	25/15
		Ilford Pan F	32/16
		Kodak Panatomic-X	50/18
Medium	Moderate grain; general-purpose films	Agfapan 100	100/21
		Ilford FP-4	125/22
		Kodak Plus-X	125/22
Fast	Grainy; ideal in low light	Agfapan 400	400/27
		Ilford HP-5	400/27
		Kodak Tri-X	400/27
Super-fast	Very grainy; for very low light or for grain effect	Kodak 2475 Recording film	1000-3200*

*ISO of Kodak Recording Film depends on processing times

Some Color Films

FILM TYPE	CHARACTERISTICS	FILM NAME	ISO
Color Slide Films			
Very Slow	Extremely fine grain	Kodachrome 25	25/15
Slow	Very fine grain	Kodachrome 64	64/19
	Good grain	Agfachrome 64	64/19
		Ektachrome 64	64/19
Medium	Moderate grain	Agfachrome 100	100/21
		Fujichrome RD 100	100/21
		Ektachrome 200	200/24
Fast	Grainy	Ektachrome 400	400/27
		Fujichrome RD 400	400/27
Color Print Films			
Medium	Moderate	Kodacolor 100	100/21
		Fujicolor FII	100/21
Slow	Grainy	Kodacolor 400	400/27
		Fujicolor 400	400/27

CLOSE-UPS

Although the term "scenic" implies broad vistas to many people, a scenic photograph encompassing no more than a fraction of an inch of scenery can effectively present an entire landscape in microcosm. When the goal of a photograph is to convey mood, feeling, or an idea, a close-up can be just as effective a means of expression as a stunning panorama. Moreover, in many instances the same lighting conditions that discourage a panorama shot can be ideal for a close-up. Finally, if a photographer's goal is to produce a photo-essay of an area, the close-up detail shot is often vital to a balanced, comprehensive presentation.

Small-format cameras have greatly facilitated close-up photography. With cumbersome view cameras, the process of taking close-ups is awkward at best, while today, small-format "macro" lenses permit a photographer to switch from normal to close-up photography at the twist of a ring.

Previewing a scene. Frequently, the camera must be positioned precisely to keep the entire subject in focus. Likewise, the extent to which the background is in focus or out of focus can be critical, especially in cases where the background is distracting. Use of a depth-of-field preview button (if the camera has one) to evaluate focus can ensure all is in order. Sometimes, however, if the lens is to be closed down to a small aperture, there will not be enough light to see a clear image in the viewfinder.

Tripod. One item of equipment is usually mandatory for close-up photography: a tripod. The problem is not necessarily that camera shake will produce a blurred image—although close-up photography often does require slow shutter speeds—but that macrophotography involves very shallow depths of field. Indeed, depths of field of less than one-half inch (1 cm) are commonplace, and a tripod is necessary to prevent the area of sharp focus from changing between the time the scene is composed in the viewfinder and the time the shutter is released.

Lighting. Macrophotography is best accomplished in the absence of strong, contrasty light. The bright highlights and deep shadows produced by direct sunlight are difficult to control. The most favorable conditions for macrophotography are usually under an overcast sky or deep in a wooded area where the light is very diffused.

Sometimes the harshness of direct sunlight can be reduced by covering the area to be photographed with a sheet of translucent plastic. Alternatively, white cardboard can be placed so as to reflect light into shadows and thereby reduce contrast to some extent.

Background. The background of a macrophotograph often presents a problem. The ideal is to have the subject set against a contrasting background, but often the natural conditions are such that the background is unattractive or distracting. A solution that frequently works is simply to place a sheet of white or black cardboard behind the subject to create a smooth, contrasting background. □

Confusing backgrounds are often a problem in close-up photography. Fortunately, in most close-up situations the solution is easy.

In the small photograph above, the intricate pattern of a sprig of Queen Anne's Lace is diluted by the similarity in tone and pattern between the flower and the background.

In the larger photograph the distracting background has been obscured by the simple expedient of surrounding the flower's stem with a dark-colored sweater, placed far enough away to be outside the range of the lens's depth of field.

Using clothing as a background is more effective in black-and-white photographs than in color, where the presence of a man-made color is usually readily apparent to a viewer.

CHOOSING THE TIME OF DAY

Everyone recognizes that light changes as the sun moves across the sky, but photographers must be able to anticipate how changes in the sun's position and intensity will affect the light striking a scene. Specifically, photographers must be able to predict the *quality* of sunlight at different times of day and estimate the effect of the sun's position on shadows in the scene.

Light quality. The term *light quality* is applied to the way in which light affects the appearance of objects. Gross differences in light quality, such as the difference between the "warm" light at sunrise and the "hard" light at midday, are readily detectable even to the untrained eye. But good photographers are sensitive to subtleties. Immediately after dawn and just before dusk, especially, light quality changes rapidly and a delay of only a few minutes can alter a scene radically.

Variations in light quality do not result directly from the sun's change in position but from atmospheric influences on the colors, intensity, and dispersion of the sun's rays. As the amount of atmospheric moisture and dust through which the rays must pass changes, the appearance of objects illuminated by the rays also changes. Since most people are unaware of subtle, minute-by-minute changes in light quality, photographers must train their eyes—and their "minds' eyes"—to appreciate and anticipate these changes as they occur during the course of a day and under a broad range of weather conditions.

Shadow. Changes in the sun's position do have a direct effect on shadows, of course, and the nature of the shadows produced often has great influence on a photograph. The direct, hard light of midday produces shadows that project straight down, often distorting the true appearance of an object. In addition, bright sunlight produces such a strong contrast between highlights and shadows that a film's ability to reveal highlight and shadow detail is frequently exceeded.

When the sun strikes an object at an angle about 45 degrees relative to the camera, the shadows reveal surface features quite accurately and lend a feeling of three-dimensionality to a scene and to the objects within it. Often a scene that looks dull and flat when the sun is overhead will acquire a radically different appearance when the sun shines on the scene obliquely. With the help of a map and a compass, a photographer can determine, in advance, if he will be rewarded with better shadows by waiting a few hours or by returning the following morning.

Shadows also can play an important compositional role in a photograph. Sometimes an interesting shadow can itself form the subject of a photograph or can be used to lend visual balance to a composition. And the presence of shadows along the ground can enhance the feeling of spaciousness and depth in a scene.

Most photographers find that both the quality of the light and the nature of the shadows generated are most pleasing in the intervals shortly after dawn and shortly before sunset. Midday is usually most useful for exploring an area to determine when and from where the best photographs can be taken. □

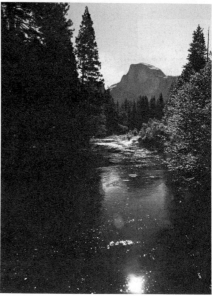

A photographer must adapt to the different light conditions present at different times of the day.

At mid-morning or mid-afternoon, sunlight strikes upright objects, such as Half-Dome, at enough of an angle to reveal the contours of the mountain clearly and reveal detail accurately (top photograph).

At midday, the combination of the sun striking Yosemite's Half Dome from overhead and the presence of atmospheric haze reduces detail. Including more foreground and incorporating the sun's reflection shifts the emphasis of the photograph slightly (lower photograph).

At right, the late afternoon sun illuminates the mountain brightly, but because the light strikes the face of the mountain from almost the same angle as the camera, detail is lost. Foreground trees are in shadow and receive a large amount of visual attention because they appear as silhouettes.

(Note: where the sky appears dark, a red filter was used.)

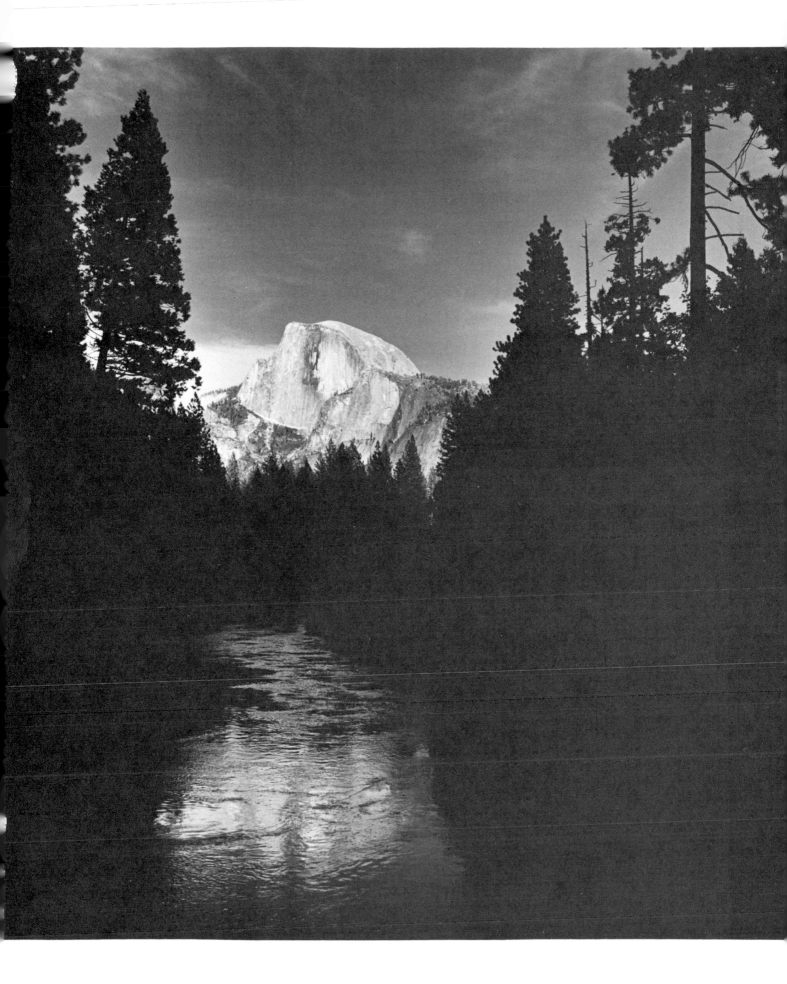

BLACK-AND-WHITE FILTERS

Most modern black-and-white films are panachromatic; that is, they respond to all colors in the visible spectrum. In theory, the films are designed to render the tones in a scene in a manner that is considered to be "natural"; however, what appears "natural" to one person may appear unnatural to another. Moreover, with the presence of color, sometimes objects that contrast well against each other to the eye appear on film as identical black-and-white tones.

Filters work by blocking some colors while allowing others to pass. In a black-and-white photograph, any color that is blocked by a filter appears black (or at least darker) in the final print. Therefore, by using the appropriate filter to darken some colors selectively, a photographer can adjust the relative lightness and darkness of tones.

The most common problem that filters are used to remedy is a lack of contrast between sky and clouds. Filters containing the color red provide the missing contrast; the greater the proportion of red present in the filter, the stronger the effect. A yellow filter darkens the sky slightly (just enough to render sky and clouds with "normal" contrast), an orange filter darkens the sky somewhat more, and a red filter, which blocks the colors blue and green entirely, produces an almost dead black sky. In the resulting photograph, the clouds stand out clearly against a dark, dramatic background. Which filter to use is a decision that depends entirely on the creative intent of the photographer.

Red filters can also have an effect on haze. Frequently, haze in the sky assumes a bluish hue, as exemplified by the characteristic color from which the Blue Ridge Mountains obtain their name. A red filter will have the same effect on this bluish hue as on the sky: the color will be darkened. Thus, a red filter darkens mountains and makes the presence of haze much less apparent. However, just as haze can appear blue, so can shadows. Therefore, an unwanted side effect of using a red filter can be a darkening of the shadows in a scene and the loss of detail as a result.

The other filter most frequently associated with outdoor photography is yellow-green, which blocks all colors *except* yellow and green. Since the colors yellow and green occur most frequently in foliage, a yellow-green filter has the effect of making foliage appear lighter than the non-foliage elements in a photograph.

Because filters block light, the presence of a filter affects exposure. But because they block some wavelengths of light more than others, color filters make through-the-lens meter readings inaccurate. Therefore, exposures must be adjusted manually, in accordance with the filter factor assigned to the filter being used (see accompanying box). □

Filter Factors

Filter factors are customarily engraved on the mounting ring of the filter to provide a basis for calculating the change in exposure produced by the filter. A factor of 2 indicates that the exposure must be increased by 1 f-stop, of 4 by 2 f-stops, and of 8 by 3 f-stops.

The procedure is to measure the scene either with a hand-held light meter or, in the case of a through-the-lens meter, without the filter on the lens. Before the photograph is taken, the lens must be opened the required number of f-stops. (Automatic cameras must first be set to manual operation.)

An alternative method is to change the light meter's ISO setting to a new value calculated by dividing the first numeral of the film's rated ISO by the filter factor. For example, for a filter with a factor of 2 being used with ISO 400/27 film, the ISO setting would be changed to 200/24. (The second numeral, "27" in this instance does not behave in the same manner as the first numeral and should be ignored when using this method.) The meter can be relied on to correctly compensate for the presence of the filter.

Because colored filters affect the ability of through-the-lens meters to produce accurate exposures, exposure compensations must be calculated on the basis of filter factors. With polarizing filters, the through-the-lens meter reading will be correct.

Black-and-White Filters

COLOR	WRATTEN NUMBER	PURPOSE	FILTER FACTOR	F-STOP CHANGE
Medium Yellow	8	Make sky natural	2	+1
Yellow-Green	11	Lighten foliage; darken sky	4	+2
Deep Yellow	16	Darken sky	2.5	+1⅓
Red	25	Darken sky dramatically	8	+3
Polarizer	—	Darken sky at approximately 90° sun angle. With Red No. 25 gives black sky.	2-4	+1 or +2

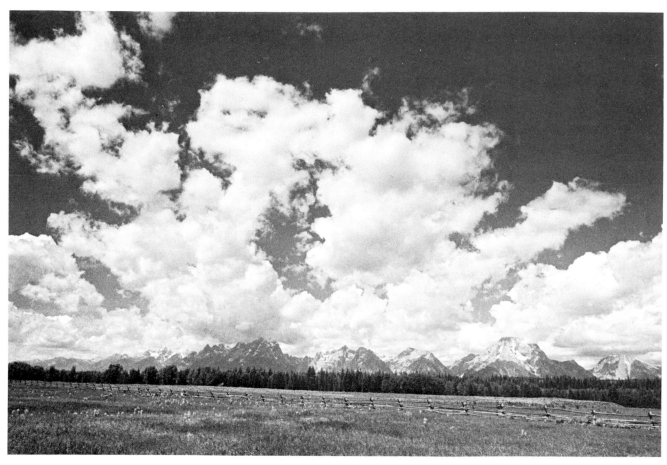

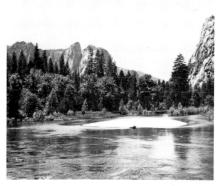
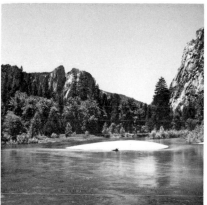
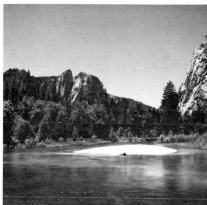

Without the use of a filter with black and-white film, the sky will often appear white or pale gray in a print. Filters darken the sky in various degrees. The effect is most noticeable and effective when fleecy clouds are present (top photograph).

In the photograph at left, above, the sky was photographed in the absence of a filter. In the middle photograph, a yellow filter added the amount of tone to the sky that is generally considered to be "normal." Many photographers routinely mount a yellow filter on their lenses when taking outdoor photographs.

The orange filter used to take the photograph on the right darkened the sky even more. In the upper photograph, a red filter was used to achieve the greatest amount of darkening.

Filters also produce collateral effects. In the three lower photographs the filters also affect the appearance of haze and the darkness of shadows. In the right photograph, some shadows have become so dark that a substantial amount of detail has been lost among the trees.

RUNNING WATER

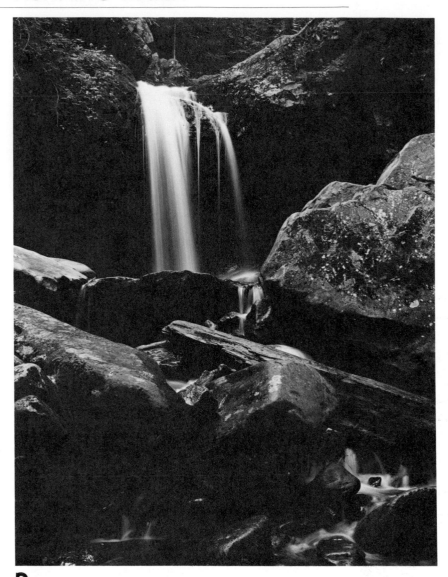

Often, the best conditions for taking a photograph of moving water occur in dense shade or under an overcast sky. In direct sunlight, high-contrast blotches of light are commonly present, and the brightness may prevent the use of a sufficiently slow shutter speed.

Running water can be deceptive. A photographer's first impulse may be to use a fast shutter speed to "freeze" the water's motion, but the resulting photograph will usually appear unnatural. The human *eye* does not perceive flowing water as a series of individual shapes and patterns, but as a *blend* of shapes and patterns. Therefore, a slow shutter speed usually reflects the impression left by a body of moving water more accurately than a fast shutter speed.

Slow shutter speeds introduce the potentially disruptive effects of camera shake, however, so a tripod is almost always necessary. With a tripod, shutter speeds as long as 60 or 90 seconds are possible, and sometimes desirable.

Because the effects of a long shutter speed are difficult to anticipate, many photographers *bracket* shutter speeds. That is, a series of photographs is taken, each one at the proper exposure but at a different shutter speed. Usually, one frame from the series will exhibit an optimal amount of blurring, although which of the frames that will be is often difficult to predict. □

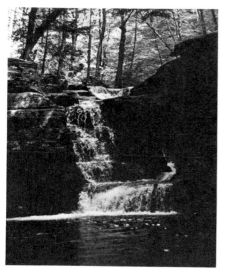

1/250 sec.

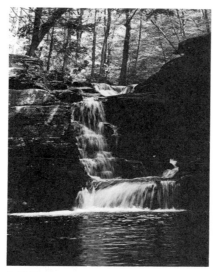

1/15 sec.

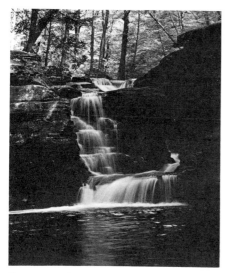

2 seconds.

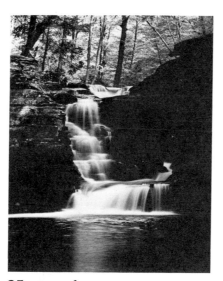

25 seconds.

The appearance of running water in a photograph is greatly dependent on the shutter speed used.

In the photograph at upper left, the motion-stopping capability of a 1/250 sec. shutter speed produces an unnatural effect: the eye never perceives flowing water as frozen in midair.

At upper right, a shutter speed of 1/15 sec. permits enough water to flow by, while the film is being exposed, for the image of the water to begin to blur. The blurring suggests movement.

At lower left, the 2-second shutter speed gives a realistic impression of the water's movement. Enough whiteness is created to give the impression of a faster rate of flow than is actually present.

At lower right, 25 seconds is too long an interval to allow the shutter to remain open. So much water has flowed by that detail has been lost: the flow seems unnatural.

The best shutter speed will depend on a waterfall's actual rate of flow, but will usually range between 1 second and 8 seconds. (The photograph on the previous page was photographed at a shutter speed of 8 seconds.)

Reciprocity Failure

Films are designed so that at normal shutter speeds a reciprocal relationship exists between shutter speed and lens aperture. That is, a change of one f-stop in one direction (for example, closing the lens from $f/8$ to $f/11$) will be compensated for by a change of one shutter speed in the opposite direction (for example, from 1/250 sec. to 1/125 sec.).

At unusually slow shutter speeds, this reciprocal relationship fails and underexposure results. In such a situation, closing the lens by one f-stop will require that the shutter remain open *more* than twice as long to produce the same exposure. With color films, reciprocity failure produces color shifts, as well, that must be corrected with filters.

Each manufacturer publishes reciprocity failure figures indicating the approximate shutter and filtration compensations to make. Because scenic photography so often requires long shutter speeds, a photographer should be aware of the reciprocity failure characteristics of each film used.

SHOOTING THE SUN

If the sun is sufficiently obscured, the meter reading can be taken directly, with the sun fully evident in the viewfinder. However, the sun's image should always be offset in the frame while the reading is being taken to prevent a "center-weighted" meter from closing down the lens too far.

Sunsets are among nature's most beautiful and awesome events. Many sunsets produce spectacular photographs without any more effort from the photographer than it takes to determine the best exposure. Yet taking photographs that incorporate the sun can pose difficult exposure problems. The secret to success is to make certain that the sun is not shining at full strength directly into the camera when the photograph is taken.

One of the easiest ways to control exposure of the sun is to wait until clouds or atmospheric haze is acting as a natural filter. As a general rule, if a photographer can glance at the sun directly without being overwhelmed by its brightness and forced to look away, it is probably subdued enough to be photographed.

The correct exposure setting depends on the sun's intensity and on the lens being used. The larger the lens makes the sun appear in the frame, the more the lens needs to be stopped down. The technique for metering the sun through the lens is to take a reading with the sun just out of sight in the viewfinder. The brighter the sun and the longer the lens, the farther out of view the sun should be. (Acquiring accuracy takes practice.) The exposure indicated by the meter serves only as a starting point. An exposure should be made at that setting, at one *f*-stop smaller, and at one, two, and even three *f*-stops wider (at the same shutter speed). □

Reflections present the same technical problems as the sun itself. A reflection should be metered just as if the sun itself were in the frame, but the actual exposure should be made with the lens opened one additional *f*-stop.

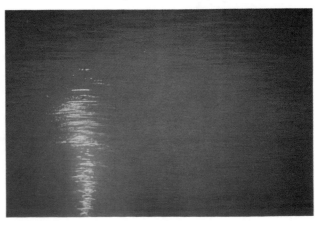

If the proper distance relationships are established, even close-up photographs can incorporate the sun.

At right, because the point of focus is close to the lens, the sun appears larger than it normally would, and out of focus.

Almost always when the sun is included within the frame, other objects will fall into silhouette. The sun's irregular shape in this photograph occurs because the lens was stopped down so far that the sides of the lens diaphragm created a hexagonal border around the sun's image.

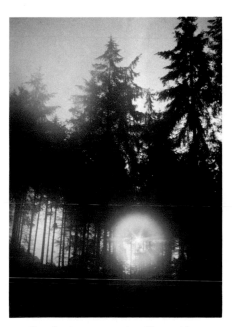

Combining a warming filter with a special effects filter often produces striking results.

Here, a color filter was used to warm the scene slightly, and a star filter to generate the star effect. Positioning the sun partially behind the trees balances the exposure and prevents the trees from falling into full silhouette.

The slight overall softness was given to the photograph by breathing lightly on the lens. The precise degree of softness was achieved by waiting until the fog had partly cleared.

Without the added color, the star filter, and the softness, this photograph might have been a more accurate rendition of the way the scene looked but would have been less representative of the way it felt.

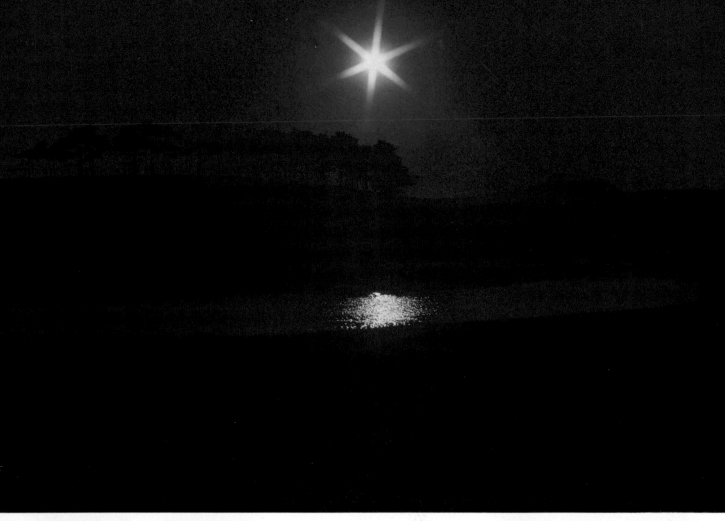

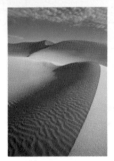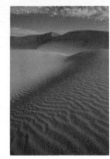

Some color filters alter color subtly and in ways that appear natural, while other filters produce color shifts that are obviously artificial.

The sand dune in the two photographs above was photographed without a filter (small photograph, above left) and through an 81A filter (small photograph, above right), which is normally used to adjust the color balance of indoor films. The filter's effect was to "warm" the tones in the scene in a way that a viewer is not likely to recognize as having been produced artificially.

Some manufacturers sell color filters specifically designed to permit the easy attainment of a wide variety of effects.

The sand dunes, photographed without a filter in the top photograph at right, are seen in the two lower photographs as photographed through Spiratone Colorflo® filters. When these filters are used with a polarizing filter, rotating the polarizer varies the color added from negligible to intense.

The colors in the middle photograph result from the influence of a yellow Colorflo® filter set to intermediate intensity. In the bottom photograph, a red Colorflo® filter was set to its deepest intensity.

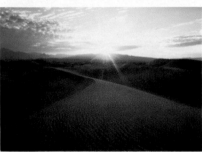

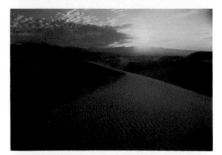

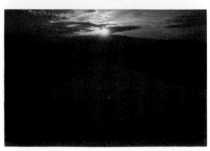

ALTERING COLOR

Filters can simulate the visual effect produced by a rising or setting sun. The photograph at left was taken in the late afternoon while the sun still stood relatively high in the sky. A red filter produced deep red tones that make the scene appear to have been photographed later in the day than was actually the case. A six-sided star filter added visual interest.

To tone down the sun's intensity, exposure settings must be used that also cause a loss of detail in foreground objects. As a result, photographs that include a brilliant sun within the frame emphasize the shape and outline of objects, rather than surface detail. A photographer must remember that even though foreground detail is apparent to the eye, the detail will not be recorded on the film.

If a photographer's goal is to reproduce on film exactly what he sees with his eyes, he is chasing a phantom. In the process of translating the scene onto film, changes inevitably occur, whether in the relative sizes of objects, shapes, sharpness, color, or anything else. While nobody should fault a photographer who wishes to remain as faithful as possible to the original scene, neither should anybody fault a photographer who wishes to alter the scene in any manner he chooses in pursuit of an image.

Some of the most vibrant colors to be found in nature are associated with sunsets. But not every sunset is spectacular, and the most vibrant colors of a sunset are usually present only in a narrow band along the horizon line. In such circumstances—or merely because a different hue may support the photographer's intent better—a photographer may wish to augment the colors actually present by employing color filters.

One common reason for using color filters is to achieve a monotone effect. When viewing a sunset, the human eye tends to concentrate on a limited area. When the same scene is reproduced in a photograph, however, the eye wanders more, and a dull gray sky that was previously ignored suddenly appears prominent. By shooting through a colored filter, the photographer introduces an overall hue to the photograph. The net effect may actually be closer to the true feeling the scene projected at the time the photograph was taken than an unaltered photograph could have conveyed. Moreover, the warm overall tone produced by a red or orange filter can be quite appealing in its own right.

Although color filters are most often used when photographing the sun, other filters are also sometimes appropriate. For instance, cool wooded areas can sometimes benefit from the addition of a blue or green tone.

Variable density filters (manufactured by Spiratone, Inc. and called Colorflo®) provide a means for selecting exactly the amount of supplementary color required by a scene. Mounted on a lens along with a polarizing filter, variable density filters generate a range of color saturations as the polarizer is rotated. The red and yellow filters are the most useful, but blue and green are also available. An 85A filter, normally used for adjusting the color balance of film, can also be used to provide a warm tone to many scenes.

In black-and-white photography, the effect of color filters is not to change color, but relative tone. As previously discussed, yellow, orange, and red filters alter the amount of contrast between sky and clouds, and other filters produce similar effects on foliage. □

COMPOSITION

Mastery of composition—the selection and arrangement of visual elements in a photograph—is one of the most difficult challenges a photographer faces. The way visual elements are organized bears directly on the message a photograph conveys, on the emotions the photograph elicits in a viewer, and even on the way the viewer's eye moves across the image. Because composition constitutes the grammar and syntax of the graphic arts, a photographer lacking a feeling for ways in which a photograph can be composed effectively is severely hampered in attempts to communicate ideas visually.

Artists follow their instincts primarily, and compose their works on the basis of a "feeling" for what looks pleasing. However, over the centuries, attempts have been made to establish some rules that those who lack an intuitive sense of composition can follow.

Rules of composition are a mixed blessing. To the extent that they help a photographer develop an understanding and feel for visual balance, they are valuable learning tools. But to the extent that they act as a substitute for thought and imagination, rules of composition can constrict a photographer's artistic development.

Far more valuable is an understanding of the principles that underlie the rules of good composition. Without exception, the best scenic photographers have mastered these basic principles and exploit them with unusual effectiveness.

Awareness of a few underlying principles can help. The first principle is that good composition is logical. Each element in a photograph should be present and located in a particular position *for a reason*. The reason need not be conventional, it need not even be articulated by the photographer, but it should exist. Without this logic, the placement of elements—and hence overall composition—is random, haphazard, and incoherent.

The reasons may be either physical or aesthetic. A physical reason is simply to control a viewer's eye movement and direct attention where the photographer wants it. Incorporating directional lines that point to a subject or foreground elements to frame it are obvious examples. Aesthetic reasons encompass any placement or usage that will help convey to a viewer a sense of the photographer's message. For instance, a viewer responds differently to a line depending on whether it is straight, curved, pointed, or jagged. By carefully selecting the shape of the lines in a photograph and positioning them advantageously, the photographer can exercise a substantial amount of control over the emotional impact a photograph makes.

The second principle is that the photographer should always know what he is photographing—and why. Photographing a scene merely because it is "appealing" results in "postcard photography." A photographer needs to determine specifically *what* it is about the scene that he finds appealing. Is the scene worth photographing because of its lushness? or its overpowering magnificence? or its solitude? or its wetness? or its peacefulness? or its color? By identify-

Constructing an effective composition requires that a photographer combine a sense of the way film records light and a logical reason for the placement of elements in the photograph.
An important aspect of this photograph's composition is the way the silver color of the dead cypress branches contrasts with the ground. In the original scene, the contrast was much less apparent. It was necessary to evaluate the elements present in the scene in terms of how they would appear on film, then to manipulate the elements through choice of position and exposure in order to arrive at the desired effect.
However, despite the strong visual impact of the branches, their pattern is more the subject of this photograph than the branches themselves. This particular lens (wide-angle) at this particular location produced a foreground that attracts the eye and carries it irresistibly across the middle ground and finally into the mass of trees at the rear of the scene. This lens and position were selected specifically for the particular visual effect they generated. Had such deliberate intentions not been present, this would have been a weak photograph.

ing what he is photographing and why he is photographing it, a photographer establishes a basis for deciding what aspect of his photograph will be his visual focus.

The third principle is that a photograph should be "built"—the image should be assembled step-by-step in the mind's eye. The scene in the viewfinder should be considered a blank field within which a main subject will be placed and supporting elements added. Every element visible in the viewfinder should be questioned. Any elements that do not support the main subject should not be included, and any elements that support the main subject only weakly should be either eliminated or strengthened. For example, take a sprig from a tree branch that intrudes slightly at the top of the frame. The photographer can either eliminate the sprig entirely or convert it into a strong visual frame around the subject just by changing camera position.

In a carefully "built" photograph, the main subject may occupy only a small proportion of the frame but will nonetheless dominate the photograph.

The placement of elements in a photograph can almost irresistibly direct a viewer's eye movement. For example, when a photographer wishes to create a feeling of great depth, he can orient foreground elements so that they catch the eye and lead it systematically toward the main subject. Much of the feeling of expansiveness that characterizes scenic photography results from a combination of careful control of eye movement through foreground elements and the wide angle of view provided by short focal-length lenses.

Good composition is difficult to achieve because of differences between the way the eye and the camera see. The eye is the more selective of the two, concentrating on some objects and ignoring others. Trees which to the eye might seem prominent in a scene, in a photograph might blend into the background. A photographer must therefore cultivate an ability to identify such discrepancies and learn to make appropriate adjustments to render the elements in a scene so that they appear with the desired emphasis. For instance, the trees in the above example might need to be silhouetted against the sky to achieve the correct compositional effect.

These three principles—a photograph should be composed logically; the photographer should know what he is photographing and why; and compositions should be "built"—are so fundamental to good composition that a photographer disregards them at his peril. Striving to observe them is an extremely effective means for developing an intuitive feel for effective organization of the elements in a photograph. Rules are merely specific applications of general principles. Rules can be followed for guidance, or they can be broken for effect, but the underlying principles invariably apply. ☐

Placement of the horizon line can completely alter a photograph's meaning.
The above photograph contains two areas of visual interest: the foreground bush and the cloud-filled sky. Placing the horizon in the middle of the photograph results in an ambiguous composition: the eye is torn between the bush and the sky, and does not find a natural resting place. Because of this conflict, the background mountains receive almost no attention.

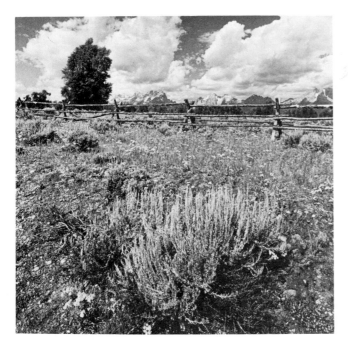

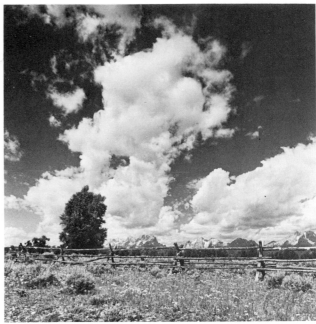

Shifting the position of the horizon line higher in the frame dramatically alters the photograph. No longer distracted by two subjects, the eye is strongly attracted only to the foreground bush. The clouds are still visible, but add interest without vying with the bush for attention.

Shifting the horizon line low in the frame again alters the photograph significantly. Because the clouds now occupy the major share of the frame, they become the new, uncontested center of interest.

Moreover even though the mountains are no larger in this photograph than they were in the photograph at far left, they are more prominent. The eye, not being drawn between two major centers of interest, is freed to explore the frame more thoroughly. The mountains serve as a resting point for the eye and provide respite from the visual dynamism of the clouds.

Even when the horizon line is not actually visible, it has a psychological presence that should be considered. A photograph in which the horizon line is inappropriately placed appears unbalanced to a viewer, even if the viewer cannot specifically identify the source of the unbalanced feeling.

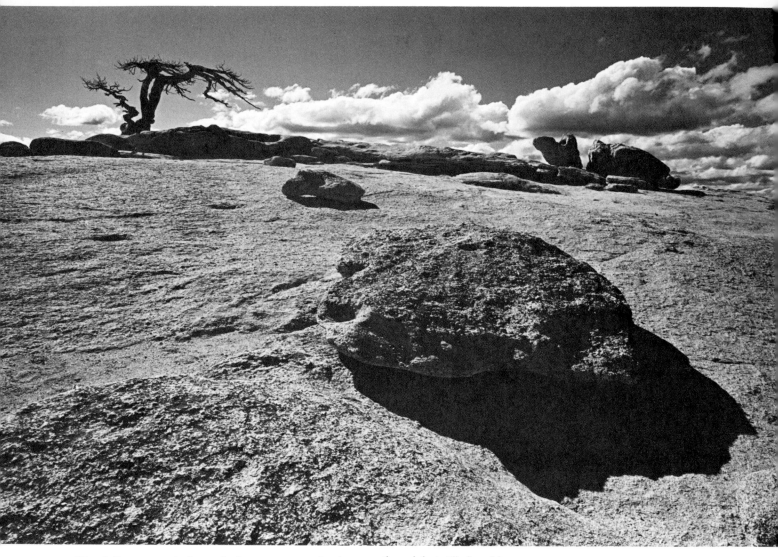

This Jeffrey pine, which overlooks Yosemite Valley atop Sentinel Dome, has been the subject of many well-known scenic photographs.

Although the tree survived the ravages of a harsh environment for centuries, in recent years it was subjected to the dual onslaught of old age and the depredations of man. Recently the tree succumbed, and the last vestiges of its life have ebbed away.

The photographer had visited Sentinel Dome before, so as he approached the top of the steep hike that leads to the summit of the dome he thought he knew what to expect: a tree weathered, but still alive. He was surprised to find that it had died.

This photograph is therefore much different from the photograph he would have taken if the scene had conformed to his expectations. In the past, the tree offered living respite from the harshness of the setting; today, the tree only re-emphasizes that harshness. As a result, in this photograph the photographer intentially composed all the elements to reflect the enormous feeling of loneliness and desolation that he felt. Had the tree been alive, he would have composed this photograph entirely differently.

In a "tight" composition, all the elements present in a photograph support its subject.

The photograph at left illustrates a "tight" composition because all elements direct attention to the tree. The rocks, although large, do not dominate. Because they are made of the same material as the surrounding surface, they serve only to guide the eye from foreground to middle-ground and ultimately to the tree.

Similarly, both the clouds and the horizon line point toward the tree. And if all these elements are considered together, an imaginary line formed by the rocks combines with the line of the clouds to generate a psychological arrow that again directs attention to the tree.

Finally, because the eye is automatically attracted to points of high contrast within a frame, the eye is irresistibly drawn to the tree. The result is that, even though it is a relatively small element, the tree dominates the entire photograph. In short, every element included in the frame either focuses attention on the tree or supports the feeling the photograph is meant to create.

The composition at right is likewise "tight," but in addition it illustrates that lens choice is a compositional decision. No direct visual clues exist in the photograph to suggest how far away the small plants lie, but the wide-angle lens clearly produces a feeling of great depth.

Conventional rules of cropping can aid in developing a feel for composition, but sometimes an image is more powerful if the rules are broken for effect.

The two photographs shown here of nearby trees on a misty hillside in the Great Smoky Mountains were taken within a few minutes of each other. The photograph at right conforms to conventional rules: the vertical subject is photographed in a vertical format, the tree lies on one of the imaginary vertical grid lines of the Rule of Thirds (see diagram), the horizon lies along a horizontal grid line, and the main subject is placed prominently in the foreground. Although the above photograph breaks the Rule of Thirds, nonetheless, its composition is far superior to that of the other photograph. The horizontal format, combined with the way in which the tree is cropped by the frame, emphasizes the spread of the tree's branches, rather than its height. Especially important, centering the subject—normally to be avoided—calls attention to the tree's asymmetry. The first photograph directs little attention to the tree's shape, while in the second, the tree's shape actually becomes the subject of the photograph as a result of the unusual composition.

POSITIONING THE SUBJECT

A common device traditionally relied on for composing photographs is known as the Rule of Thirds. The rule involves dividing the photographic frame into thirds, as illustrated in the diagrams above and at right. The subject is placed at one of the line intersections in the grid and the horizon is placed along one or the other of the horizontal lines. This rule is only one of many possible systems that can be used as guides in composing photographs. The only hard and fast rule is that the placement of elements follow some logical design that supports the photographer's purpose in taking the picture.

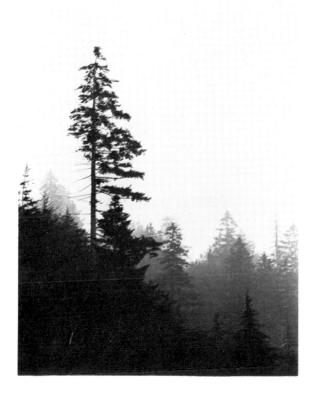

Centering the subject. Perhaps the most telling sign of a lack of awareness of composition is the centered subject. Only under very specific circumstances should the main subject of a photograph be located at the geometric center of the frame.

The main reason for this is that the center is a neutral position: a centered subject receives little emphasis. No aspect of the background appears more important than another, and so the viewer usually can draw few conclusions about the relationship the background has to the subject. Generally, the only circumstance in which centering is appropriate is when the photographer specifically intends to convey a feeling of symmetry.

The Rule of Thirds. A traditional device for positioning the major elements in a photograph is often referred to as the Rule of Thirds. The scene in the viewfinder is mentally divided into thirds, both vertically and horizontally, and the main subject positioned at one of the four points where the imaginary lines intersect. Generally, the horizon is made to coincide with one or the other of the two horizontal lines.

The main virtue of the Rule of Thirds is that it supplies a rationale for composing a photographic frame. Furthermore, photographs composed in conformity to the Rule of Thirds automatically position the subject off-center in the frame. By shifting the subject to one side, an interaction begins to take place between subject and background. The space on the other side of the frame becomes "active." Unconsciously, a viewer relates the subject and the active space, as if to answer the question, "Why did the photographer choose to include this piece of space rather than another?" Thus, the way the photographer offsets the subject contributes to a photograph's message.

Care must be taken in deciding at which intersection to place the subject. In photographs containing people, a photographer should compose the scene so that they gaze into the frame, not out of it. The same holds true in scenic photography. Even inanimate objects have a psychological "weight," and attention must be paid to where the weight is placed in the picture and which way it is leaning.

The main disadvantage to the Rule of Thirds is that it can be overused. Not all scenes lend themselves well to this type of composition, and if the rule is followed mechanically it can stifle creativity. The only important criterion that always remains is that the compositional arrangement follow an underlying logic.

Angle of View. Customary perspectives are frequently trite. By avoiding the most obvious viewpoint, a photographer can add impact to photographs and alter substantially the messages they convey. For example, a flower presents entirely different messages depending on whether it is photographed from above or from the side. From above, the flower might appear fragile and vulnerable. From the side and up close, the flower might assume a new prominence that flows directly from the change in angle. By being willing to find the most interesting angle, a photographer increases the ability to express a diverse range of ideas even with everyday subjects. □

DETERMINING EXPOSURE

Even though the days of estimating light intensity by eye are long past, and despite the presence within many cameras of built-in light meters, obtaining a proper exposure is still a skill that must be mastered by anyone who wishes to be in control of the medium of photography.

Light meters are unthinking devices, designed only to measure light intensity and then indicate which exposure settings will cause the amount of light being measured to appear in a photograph as a standard, neutral gray tone (formally defined as *18-percent gray*). The problem is that not all scenes are best rendered with an average 18-percent-gray tone. Moreover, different kinds of meters exist and, in many circumstances, no one type will yield enough information to allow calculation of the settings that will yield the best exposure.

Incident-light meters. Incident meters are designed to measure the amount of light falling on a scene. An incident-light reading usually gives a good average of the light intensities in a scene. If a scene is exposed at the incident settings, objects in the scene lighter than an 18-percent gray will appear lighter than 18-percent gray in a print, and objects that are darker will appear darker. This is important in scenes where the average tone is not 18-percent gray.

Reflected-light meters. Reflected meters measure the amount of light being reflected off an object or out of a scene. Most through-the-lens (TTL) meters are of the reflective type. In a scene that on average is lighter or darker than 18-percent gray, the exposure settings indicated by the meter will make the scene record on film darker or lighter, respectively, than the scene appears to the eye. This can be a problem if the scene is of snow, for example, which will appear not white, but gray.

Combination meters. Most hand-held meters can be used to measure both incident and reflected light. The conversion is accomplished by sliding a translucent dome onto and off the meter's light-collecting sensor.

Spot meters. A spot meter is a specialized type of reflective meter. The spot meter has a restricted angle of view, which permits accurate readings to be taken of a small area. Spot meters are especially useful in scenic photography, where large distances between subject and meter limit the ability of normal reflective meters to measure the light intensity of individual objects located far away.

Meters display their measurements in two different manners. On one type of meter, the dial indicates the specific combinations of shutter speed and *f*-stop that will render the light intensity being measured as an 18-percent-gray tone. The other type, called a *nulling* meter, compares any two light intensities and indicates, in terms of *f*-stops of exposure difference, how much brighter one intensity is than the other. As will be shown later, each method has its own advantages and uses.

Determining the "best" exposure settings to use is different for color film than for black-and-white film. Color film, especially color transparency film, cannot tolerate overexposure or underexposure by more than a single *f*-stop without producing an unacceptably light or dark

Multi purpose meter

Quality scenic photography almost demands that a photographer carry a dependable, accurate light meter. Various manufacturers produce excellent models; the Gossen Luna-Pro, shown above, is typical of the better versions.

The meter operates in three modes: as a reflective meter; as an incident-light meter; and, with the optional accessory shown on the top of the main body of the meter, as a spot meter. The spot meter attachment permits measurements to be taken with an angle of view as small as one degree.

This meter uses the nulling method of indicating exposure: the meter is pointed at the object to be measured, and the dial rotated until the needle aligns with zero. Figures on the dial give the various combinations of f-stop and shutter speed that will yield an average exposure.

Once the meter has been set, pointing it at any object will cause the needle to deflect and tell how much brighter or darker the object being measured is than the light used to take the original reading.

Accurately metering a scene is a multistep process.

In the photograph above, the light meter's white diffusion dome has been slid over the meter's light sensor (situated in the middle of the front edge of the meter), so that the meter will measure incident light. In order to measure the amount of light falling on the scene, the meter is pointed toward the camera. The meter's dial is then rotated until the needle is aligned with the zero on the dial.

Below (upper photograph), in anticipation of taking a reflected-light reading, the diffusion dome has been slid to the left to uncover the meter's light sensor. The meter has been carried close to the darkest tone in which the photographer wishes to capture detail. The meter indicates that the shadow area is two f-stops darker than the incident light reading of the entire scene.

In the lower photograph, a reflective reading of the brightest highlights in which the photographer wants detail indicates that the highlights are three f-stops brighter than the incident reading.

image. Although incorrectly exposed color negatives can be manipulated somewhat in the darkroom to produce an acceptable print, that option is not available with color transparencies.

Therefore, the best procedure is to use a light meter, either reflective or incident, to determine a likely exposure setting, then *bracket* exposures. *Bracketing* refers to the process of intentionally overexposing and underexposing a scene. After the film is developed, the best single frame is selected and the others discarded. Since color film is extremely sensitive to exposure differences, the prudent procedure is to bracket by at least two half-stops on either side of the exposure indicated by the meter. The more important the photograph and the more extreme the lighting conditions, the more extensive the bracketing should be.

Black-and white film is much more "forgiving" than color film and can be manipulated extensively in the darkroom. (See Section 4). The real goal in determining black-and-white exposure settings is to ensure that the negative contains detail in the shadow areas.

Obtaining shadow detail. The first step in obtaining shadow detail with black-and-white film is to take an incident reading of the overall scene. This reading yields the basic exposure setting. The next step is to decide just how much shadow detail is important, and then find out how much darker that shadow detail is than the basic setting. (This is where the nulling type of light meter is handy.)

If the shadow detail is more than two *f*-stops darker than the basic setting, there is a great likelihood that there will not be enough shadow detail on the negative to make a good print. Therefore, the basic exposure setting must be revised until it is no more than two *f*-stops lighter than a correct exposure of the shadow area.

If the shadow detail already falls within two *f*-stops of the basic setting, then the intensity of highlight detail should be measured. As long as the highlights measure within three *f*-stops of the basic setting, they will be printable. However, if shadow and highlight detail cannot both be accommodated, the highlights should be sacrificed.

Taking these various readings is not especially difficult. Hand-held meters are easier to use than TTL meters, but either will work. With a hand-held meter, the photographer takes an initial incident-light reading, converts the meter to reflective use, and then measures the shadows and highlights—or the brightness of any other objects within the scene he cares to—individually. If distant objects must be measured, a spot meter will be valuable.

Even if he only has a through-the-lens meter, a photographer can still obtain accurate readings, but with some additional inconvenience. Instead of an incident reading, he can first use his TTL meter in the usual manner. This procedure furnishes an exposure setting intermediate between the darkest shadows and brightest highlights. Next, he takes additional measurements by carrying his camera close to the items he wishes to measure. The results should be the same as with hand-held meters.

Actually, methods exist for obtaining usable prints even when shadows and highlights are extreme. These methods are the subject of the following section. □

PORTFOLIO III

DETAILS

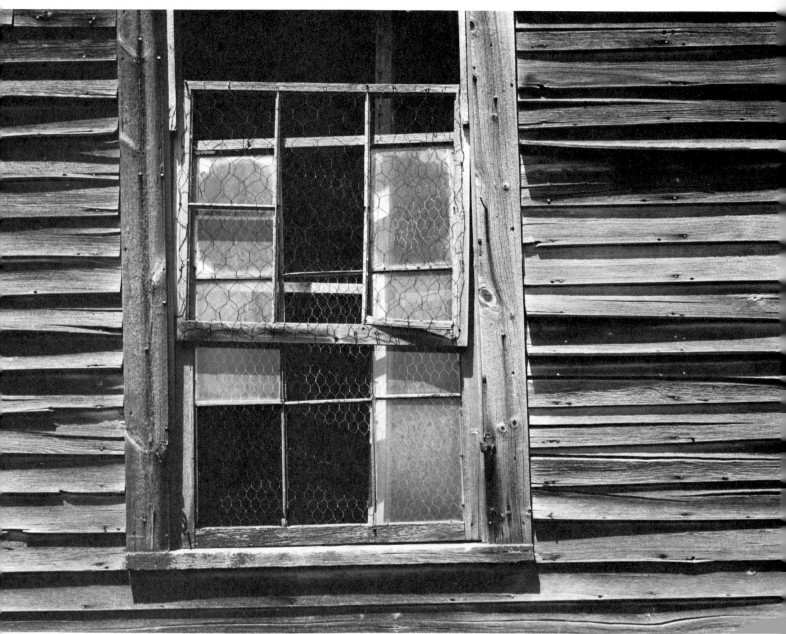

DETAIL, WEATHERED BARN

The designation "scenic photograph" suggests different things to different people. To some, a scenic photograph should not include any evidence of the presence of man. A broader definition, one that allows greater latitude in the message a photograph can contain, includes any photograph that makes a statement about a natural phenomenon—including man's relationship to nature.

Whether a particular photographer chooses to incorporate artifacts of man's presence within a photograph is a personal decision.

Nature makes no distinction between that which is man's and that which is not. All things are subject to nature's immutable laws and persistent forces.

Although the form of the building at left was shaped by the hand of man, time and nature appear to be drawing the building's facade slowly back toward a less structured state. Surely, not many years were required for the building to lose many of the patterns imposed on it by man and to acquire structural qualities similar to those displayed by the naturally-formed, water eroded rock at right.

ERODED ROCK, POINT LOBOS

A scenic photographer should not need to rely solely on the spectacular to convey his impressions of nature. Individual details can often be as eloquent as a vast panorama.
It is the relationship of light to a subject that tells the story, not the subject's physical size.

SUNRISE DEW DROP

BRANCH AT DAWN

A photographer does not always need to rely on close-up devices and lenses to suggest the fine details of a subject.

At left, the shallow depth of field of a long lens produces a neutral background against which the leaves stand out clearly. Even though the edges of the leaves are not in sharp focus, an impression of fine detail results from the way the photograph depicts the delicate overall pattern of the leaves along the branch.

*S*ometimes I experience a thrilling sense of discovery
while I am studying commonplace objects up close.
The process of searching for photographs in a tiny
world forces me to look at things carefully, even if I
don't know just what I am looking for.
We never see the objects around us from a really
close-up perspective; so the only effective way to
explore mini-landscapes is while actually peering
through a camera lens. Then, each change in f-stop
and each change in focus, minute though it might be,
exposes yet another, entirely different world.

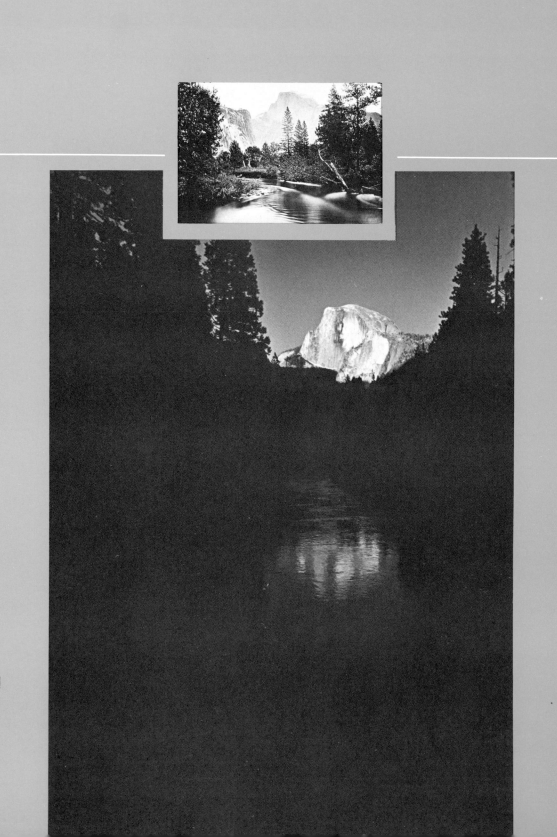

The ability of large-format cameras to capture the previsualized image can best be duplicated with small- and medium-format cameras by using a system of exposure control that does not restrict these smaller cameras' capability to explore a subject thoroughly and respond quickly to changing conditions.

4. THE VALUE RANGE SYSTEM

Sensitivity to light may be the aesthetic prerequisite to outstanding scenic photography, but the value of technical skill cannot be overemphasized. Translating what one sees in a scene onto film and ultimately onto paper is by no means a casual process.

Despite the high quality of modern films, a photographic image is not the exact equivalent of a scene; the image only *represents* the scene. Even more so with black-and-white films than with color, a substantial difference is always present between a scene as it exists in nature and the image of that scene on a negative or a print. For example, with black-and-white film, all tones and colors in a scene are rendered as black, white, or a shade of gray. Therefore, a fundamental skill a photographer must develop is the ability to translate, in his mind's eye, what he sees in his viewfinder into the photographic image that will ultimately appear on paper.

Developing this ability to "previsualize" is made all the more difficult by the inability of film to record all tones in a scene on a one-to-one basis. Film is not sensitive to as broad a range of light intensities as is the human eye, so not only will the tones in a scene undergo transformations in becoming a photograph, but some of the tones may be lost completely.

The best known method for systematizing the process of translating a scene onto film is the Zone System, developed and popularized by the respected scenic photographer, Ansel Adams. Though somewhat difficult to master, the Zone System is extremely effective and has served photographers well for decades. The careful, deliberate calculations required for the Zone System lend themselves well to the equally careful, deliberate methods demanded by large-format, "view" camera photography. However, the system is less well-suited to the type of small- and medium-format photography that has gained enormous popularity in recent years. (The reader who is interested in learning about the Zone System will find Ansel Adams's books on the subject helpful.)

The Value Range System described on the following pages is substantially easier to learn, much simpler to use, far more versatile than the Zone System, and will produce results that exploit to the fullest the unique capabilities of modern, small- and medium-format cameras. □

Inset: Half Dome from Yosemite Valley, ca. 1861, by C. E. Watkins. Nearly inaccessible in Watkins's time, this vantage point now attracts tens of thousands of visitors annually.

DENSITY AND CONTRAST

In order to use the Value Range System most effectively, it is necessary to understand some important photographic concepts.

Density. When light strikes film, a change occurs in the light-sensitive silver halide crystals coated on the film's surface. The greater the intensity (brightness) of the light that reaches a portion of film, the greater the number of silver halide crystals that react.

When film is developed, chemical processes convert the exposed silver halide crystals into metallic silver. The conversion is not instantaneous, however. The longer the developer is allowed to remain in contact with the film, the *denser* the layer of silver on the negative becomes. The density of the silver at a particular portion of a negative is referred to as that portion's *density value*.

A negative's density affects the quality of the final print. If a negative is insufficiently dense overall, detail in shadow areas will be lost. If a negative is too dense overall, metallic silver coated on the film will obscure detail in highlight areas. Consequently, the ultimate goal in exposing and processing film is to produce a negative with the optimal degree of density for generating the best possible image.

Contrast. Every meaningful photograph displays a range of different tones (shades of gray). If the tones in a given photograph proceed from black to white in a *small* number of *large* steps, the photograph is said to possess "high" or "hard" contrast. If the tones proceed from black to white in a *large* number of *small* steps, the photo is said to possess "low" or "soft" contrast.

In sections of a negative that correspond to shadow areas in the original scene, relatively few silver halide crystals are affected by light, so in the course of development, all of the exposed crystals are converted to metallic silver very soon after the film is placed in the developer solution. If, during processing, development were to be halted as soon as most of the silver halide in the shadow areas on a negative had been converted to metallic silver, little difference would exist between the respective negative densities of shadow and highlight areas. Continued processing has little effect on shadow areas; however, because most of the silver halide in the highlight areas would still be unconverted, continued processing *would* produce a pronounced effect on highlight areas. The result is that the longer the total development time, the greater the difference in density value between shadows and highlights, and consequently, the greater the amount of contrast shown by the negative. In effect, underdevelopment decreases contrast, overdevelopment increases contrast. This relationship between development and contrast forms the foundation of the Value Range System. □

Density ## Contrast

 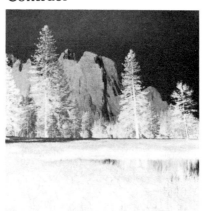

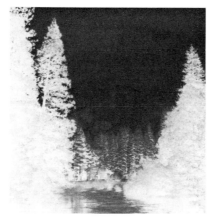

Exposure controls the density of a negative. The only difference between the two negatives directly above is a single f-stop difference in exposure.

In the top negative, density is inadequate in the trees, so in a print, no detail would be present in the tree shadows. However, density in the middle of the negative is nearly perfect.

In the lower negative, a shift in exposure has produced sufficient density in the trees, but too much density in the middle area.

The goal of the Value Range System is to provide guidelines for achieving adequate density wherever detail is desired.

The average overall density of the two negatives shown directly above is approximately the same in each, but degree of contrast differs greatly.

In the upper negative, contrast can be described as normal because the difference in tones between highlights and shadows is moderate, and there exists a broad range of different tones.

The lower negative is too "contrasty." Little detail is present in either the highlights or the shadows, and the range of different tones is extremely limited.

Only the upper negative will print with detail in highlights and shadows. The contrast in a negative can be controlled during the development process.

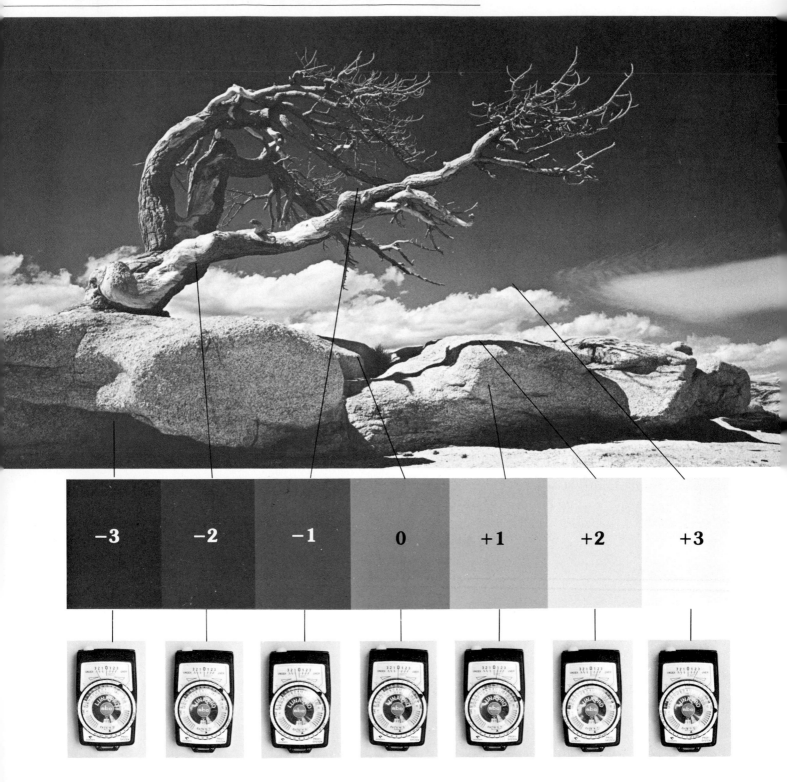

Although there are an infinite number of possible gray tones between the extremes of black and white, one particular tone, defined as "18-percent gray," has been arbitrarily selected as the standard middle tone. Light meters are calibrated to measure the average brightness of a scene and indicate exposure settings that will cause a camera to render the scene with a density on a negative that will yield an 18-percent-gray tonal value.

Standard tonal value scales ("gray scales") such as the one shown below at left are built around 18-percent gray as a common starting point. Each tone, or "tonal value," on the scale represents a measured difference of exactly one f-stop in the original scene, as indicated by the needles on the nulling meter shown underneath the tonal value scale. (Nulling meters are described on page 86.)

The tonal value scale permits a photographer to relate the brightness of any element in a scene to the way that element will appear on No. 2 printing paper. With 18-percent gray designated on the scale as "zero," any element in the scene that measures exactly one f-stop darker than a "correct" exposure will appear in a print as a −1 tone, any element that measures exactly two f stops darker will appear as a −2 tone, etc. A similar correspondence exists between overexposed elements and the "+" values on the scale.

If a scene is intentionally under- or overexposed, each tone within the scene will be shifted left or right along the tonal value scale by a predictable amount. For example, if the entire scene shown in the photograph were underexposed by exactly two f-stops, those elements which previously would have printed with a tonal value of zero would appear instead as a −2 tone, and all other tones would be similarly shifted left along the scale. Any elements that would originally have been rendered as −3 or −4, however, would record as pure black in the underexposed version of the scene.

Using nonstandard development times, or using other than No. 2 printing paper, alters the relationship between light meter measurements and the tonal value scale. The Value Range System of exposure control provides a means for evaluating a scene to decide whether the scene requires that the relationships be changed, and for determining what actions to take to produce the needed changes.

The Tonal Value Scale. Although there is an infinite number of possible tones between the extremes of black and white, one particular tone, defined as "18-percent gray" has been arbitrarily selected as the standard middle tone. Light meters are calibrated to measure the average brightness of a scene or an object and indicate exposure settings that will cause a camera to render the scene or object with a density, on a negative or transparency, equivalent to an 18-percent-gray tonal value. Standard tonal value scales (commonly referred to as "gray scales") have been developed that relate the 18-percent-gray tonal value to other lighter and darker tonal values. *Each step on such a scale represents a change in exposure of one f-stop.*

Exposure latitude. Every scene contains a range of light intensities that can be measured with a light meter. As long as the range of light intensities in a scene does not exceed a film's *exposure latitude* (the range of light intensities to which the film is capable of responding), all of the tones in the scene will be recorded as distinguishable tones on the film.

Films vary in their exposure latitude. Color films generally have an exposure latitude that encompasses three f-stops of exposure difference. That is, color film will respond to light intensities along a range of from one f-stop of overexposure to one f-stop of underexposure. Black-and-white films have an exposure latitude of approximately five f-stops; that is, black-and-white films will respond to light intensities along a range from two f-stops of overexposure to two f-stops of underexposure. Any tones in a scene with light intensities that lie outside a film's exposure latitude will record detail poorly, or will be rendered as either pure white or pure black, depending on whether the tone lies above the overexposure threshold or below the underexposure threshold respectively.

By overexposing or underexposing a scene, a photographer can shift the range of tonal values up or down the tonal value scale. For example, if a scene containing a range of seven f-stops were to be exposed in accordance with the indications of an incident-light meter (which provides a measurement of the *average* amount of light in the scene), the tonal values in the final print would all be in the range from +2 to −2 (in addition to white and black) on the tonal value scale. Any detail present that measured more than two f-stops over or under the average meter reading of the scene would probably be lost. However, if the scene were to be overexposed by one f-stop, the scene would then be rendered with tonal values in the range from +3 to −1 (in addition to white and black) on the tonal value scale. In other words, detail would be present in the print in areas that measured up to three f-stops brighter than the incident meter reading, and down to one f-stop darker than the incident meter reading.

*Under*exposing the film by one f-stop would have shifted the range of tones captured on the negative by the same amount but in the opposite direction. Over- or underexposing the film by *more than* one f-stop would have shifted the range of tones along the gray scale by a correspondingly greater amount. □

ALTERING DEVELOPMENT TIME

If a frame of film is developed normally, whichever tone the scene was exposed for will automatically appear in a final print with a tonal value of 0 (18-percent gray). Tones that in the scene measured one *f*-stop brighter will appear with a tonal value of +1, tones that measured one *f*-stop darker will appear with a tonal value of −1, and so on, until the limits of the exposure latitude of the film are reached. All remaining tones will appear as either white or black.

*Under*developing will cause each successive shade of gray to differ from the previous shade of gray by a smaller amount than the difference between shades in the tonal value scale. For example, in a print made from an under-developed negative, a tone that in the original scene was one *f*-stop overexposed will appear in the print to be slightly darker than the +1 tone on the tonal value scale. All other tones will be similarly affected. The net effect will be a print that shows *decreased contrast*.

*Over*developing produces a print in which the separation between tones is greater than in the tonal value scale. The net effect is a print that shows *increased contrast*.

The effects of altered development time do not assert themselves equally along the tonal value scale. Because shadow areas reach full development much more quickly than highlight areas, altering development time has little effect on shadows, but a great effect on highlights. As a result, the lighter the tone, the more pronounced the effect on tonal separation (contrast). However, the net effect is to alter the overall range of printable tones recorded on film.

Overdeveloping film increases the size of silver clumps ("grain") on film. With large-format negatives, the increased grain is rarely noticeable, but because small-format nega-tives must be enlarged greatly, overdeveloping by more than one *f*-stop yields prints that in most instances are unacceptably grainy.

Even though photographic film and photographic paper are closely related, paper does not respond in the same way as film to over- or underdevelopment. Papers have a much narrower exposure latitude than film, and do not respond significantly to alterations in development time. Substantial underdevelopment can produce a "muddy" image in which the black tones lack brilliance, but overdevelopment has little effect at all.

Differences exist in the proper development time for different types of paper, however. Resin-coated (RC) pa-pers, which have a plastic base, usually are fully developed within one minute of contact with the developer. Fiber-based papers require approximately one-and-one-half min-utes to reach full development. Rarely, if ever, is there any reason to deviate substantially from the manufacturer's recommended development time.

Many, if not most, scenes contain a range of tones such that film developed "normally" will yield a negative with optimal density and contrast. As will be discussed in the remainder of this presentation of the Value Range System, there will be times when lighting conditions will be extreme. By knowing how to compensate in the field and in the darkroom for these extremes, a photographer will have at his disposal a valuable photographic tool. □

Altering development time affects the contrast of a negative, and changes the overall range of light intensities, present in a scene, that film can record. When the contrast between tones has been decreased, the film is said to have been compressed. When the contrast between tones has been increased, the film is said to have been expanded. The three scales at right are a graphic representation of the effect on tones of altering development time.

In the middle is a standard tonal value scale. It represents the range of tones that would be produced by a negative that was exposed normally and received standard processing. The left scale represents a compression of one f-stop, and the right scale an expansion of one f-stop.

The step within each scale marked as "0" shows how a tone that measured 18-percent gray would appear in a print. In each scale, the "+1" step indicates how a tone that measured one f-stop brighter than 18-percent gray would print, the "−1" step indicates how a tone that measured one f-stop darker than 18-percent gray would print, etc.

As is apparent from a comparison of the scales, the dark tones remain essentially unaffected by compression and expansion. The differences reveal themselves almost exclusively in the lighter tones. The compressed scale contains one more highlight tone than the middle scale, and the expanded scale one less.

Thus, compressing or expanding a scene changes the way a particular tone will ultimately appear in a print.

COMPRESSION AND EXPANSION

In most circumstances, the ideal print utilizes the full tonal capabilities of film and paper to reproduce the entire range of tones contained in the previsualized image. As long as the range of light intensities in the scene essentially coincides with the exposure latitude of the film, the only decision that needs to be made is whether to expose normally or to over- or underexpose in order to shift all tones up or down on the tonal value scale. If a scene exceeds the exposure latitude of the film, however, or if the range of light intensities is substantially narrower than the film's exposure latitude, the tones in the scene can be either *compressed* or *expanded*.

When a scene is underdeveloped (see previous page), the change in contrast occurs because the separation between tonal values is diminished. Moreover, underdevelopment causes some of the areas that were so bright that they would have produced maximal density had they been allowed to develop fully, to be arrested at an earlier stage where they will still pass some light. In addition, if, before being underdeveloped, a scene has been overexposed, some shadow areas that otherwise would not have contained enough light to produce any reaction on silver halide crystals suddenly do make an "impression." Thus, underdevelopment alone compresses the range of tones in a scene, and underdevelopment combined with overexposure compresses the range of tones even more.

Conversely, overdeveloping a scene produces an *increase* in contrast because the separation between tonal values is enhanced. The chemical reactions can proceed more nearly to completion than occurs during "normal" processing. However, the increased contrast is usually accompanied by a loss in highlight detail due to the density of the silver that is produced being too high. (The highlights are said to be "blocked.") If the film has been underexposed before being overdeveloped, the tonal expansion is even greater and highlight blockage is minimized.

When film exposures and development times are altered, the relationship between the light intensities in a scene and the tonal values on the tonal value card no longer relate in the same way: a change in light intensity of one *f*-stop no longer corresponds to a change of one tonal value on the gray scale. Instead, the tonal increments are less (in the case of a compressed scene), or more (in the case of an expanded scene); in short, contrast has been altered.

Overexposure and overdevelopment affect not only contrast, but also film grain. However, the more film is overexposed without underdevelopment to compensate, or underexposed without overdevelopment to compensate, the greater the size of the clusters and the more noticeable the grain.

Moderately-large grain is not a problem unless a negative is to be enlarged greatly. A print generated from a large-format negative requires proportionately much less enlargement than a print of the same size made from a small negative (see page 30). Therefore, while large-format negatives can be overexposed or overdeveloped by a substantial amount before grain becomes noticeable in a print, small-format negatives cannot tolerate the same extremes. □

Compressed 2 stops

Compressed 1 stop

Normal

Expanded 1 stop

Expanded 2 stops

In the above scene, the difference between the brightest highlights on the hood of the car and the shadows in the car's wheel well measured six f-stops—too broad a range of light intensities for the film to hold. The print in the center of the cluster of photographs was made from a negative that was exposed at the settings indicated by an incident reading of the overall scene. The other photographs demonstrate how compression and expansion affect the way a scene ultimately appears in a print.

Compression and expansion effects can be studied most easily by comparing the detail evident in the highlight areas of the car hood and the dark areas in the car's shadow and on the wall of the shed.

In the left photograph, compression by one f-stop has its most noticeable effect on detail within the car's wheel well. Whereas no detail is evident in the wheel well in the center photograph, one f-stop of compression reveals individual stalks of grass growing around the wheel. In addition, detail in the shed is much improved. The highlights in the hood are slightly subdued by the compression.

In the topmost photograph, two f-stops of compression are too much for this scene. Detail in the shadow areas is increased, but the blacks are not rich, and the whites of the highlights are beginning to appear gray. (This is especially noticeable in the appearance of the sky.)

In the right photograph, expanding the scene by one f-stop has increased contrast noticeably. More areas have fallen into darkness and lost detail. Similarly, more highlight areas have gone completely white.

In the lowest photograph, an additional f-stop of expansion further compounds the losses, to the extent that even the middle tones are beginning to disappear.

CALIBRATING THE VALUE RANGE SYSTEM

Every combination of film, developer, enlarger type, paper grade, and paper brand produces its own characteristic degree of contrast. Consequently, for any system of contrast control to yield consistent, predictable results, the system must be carefully calibrated for the products and components actually being used.

Step one: Locate a sunlit scene containing a range of at least seven f-stops from the darkest shadow to the brightest highlight. Using an incident meter reading of the scene as the exposure base, expose frames at the meter reading as well as with the lens set at one-half stop and at one full stop wider (overexposed), and at one-half stop and at one full stop smaller (underexposed). Then, repeat the identical procedure four additional times. (Each of the five sets of five exposures will be developed for a different length of time. Each set can be shot on a separate roll of film, or all five sets can be shot on one roll, as long as enough space is left between each set of five frames so that in the darkroom the sets can be cut into separate strips. Because the cutting must take place in total darkness, careful planning is necessary to avoid cutting through an exposed frame.)

Step two: Develop the film after it has been cut into strips. One set of five frames should be developed at the manufacturer's suggested development time (MSDT) for the temperature being used, one at ⅔ MSDT, one at ¾ MSDT, one at 1⅓ MSDT, and one at 1½ MSDT.

Step three: Inspect the strips of film to identify the individual frame exhibiting the best density on each strip, and make a print on No. 2 paper from each of these five best frames. The enlarger lens should be set to its optimal lens opening. (The optimal lens opening varies from lens to lens, but is most often an intermediate lens aperture).

Step four: Adjust the film's ISO, if necessary. If the frame that produced the best print was on a frame that was exposed normally, no ISO adjustment is called for. If the best frame is on a strip other than the one developed at the MSDT, the film's ISO must be multiplied by the factor shown in the box (see page 110, bottom) to arrive at the film's *effective* ISO. (Thereafter, the light meter should be set at the film's effective ISO whenever that film is used.)

Step five: Establish a standard development time, which is simply equal to the development time of the strip that contains the frame that produced the best print. If the best print came from a strip other than the one developed at the MSDT, in all future use of that developer, the new development time becomes the "normal" development time.

Once the calibration process is complete, the relationship between an exposure reading and the tone that the reading will produce on No. 2 paper is standardized and predictable. Moreover, the effects of changes in exposure, development, and paper on the tones in a scene can be reliably anticipated and controlled. (See description on following pages.) □

A Note About The Paper Used For This Book

The contrast characteristics of papers vary from manufacturer to manufacturer, and even among the paper types of a particular manufacturer.

Although the process of transferring a photographic print onto a printed page introduces some unavoidable alterations in the image, the reader may find it helpful to know that all the black-and-white photographs in this book were printed on Agfa Brovira-Speed paper.

Brovira-Speed paper was selected because the sharp, slightly contrasty image it produces is less subject to alteration by the offset printing process than are images produced on most other papers.

Determining Effective ISO

If the best negative obtained from the calibration process is located on a strip that was either over- or underexposed, that film should thereafter be used with the light meter set to a different ISO rating. Calculate the new rating using the figures in the chart below.

EXPOSURE OF BEST NEGATIVE	MULTIPLY RATED ISO BY
+1 f-stop	½
+½ f-stop	¾
−½ f-stop	1½
−1 f-stop	2

A photographer cannot assume that if he relies on standard film speed ratings and development times he will automatically obtain the best possible negative. Each item of equipment and material he uses exerts an influence on the final image, and often the best combination of film speed rating and development time differs from film to film, from developer to developer, from enlarger to enlarger, and from paper to paper.

The illustration at right represents the results of the calibration test described in the text. Each strip contains five exposures taken of the same scene. In each case, frame a. is overexposed by two f-stops, frame b. by one f-stop, frame c. is exposed normally, frame d. is underexposed by one f-stop, and frame e. by two f-stops.

Each of the five strips of film was developed for a different length of time, as indicated. For example, the strip labeled "2/3 MSDT" was developed for two-thirds of the manufacturer's suggested development time.

After the strips are dry, they are examined closely and the best two or three frames are used to make prints on No. 2 paper. The print that shows the best contrast and rendition of tones indicates which was the best negative. The exposure and development that the best negative received in the test thereafter becomes the standard for that film/developer/enlarger/paper combination. (The lower box on the previous page explains how to calculate the effective ISO rating for a film type based upon the calibration test.) All compression and expansion calculations are then based upon the new, calibrated standards.

For example, a test actually run for Agfapan 100 film, developed in Rodinal (diluted 1:25), and printed on Agfa Brovira-Speed paper, using an Omega D Dichroic Head (diffusion-type) enlarger, revealed that the film should be rated at ISO 150 and developed for 1 minute at 68 F (20 C).

Development Time	+2 f-stop (Frame a.)	+1 f-stop (Frame b.)	normal (Frame c.)	−1 f-stop (Frame d.)	−2 f-stop (Frame e.)

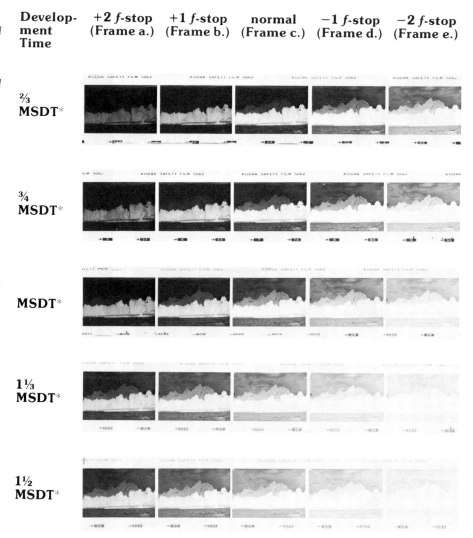

⅔ MSDT*					
¾ MSDT*					
MSDT*					
1⅓ MSDT*					
1½ MSDT*					

*Manufacturer's Suggested Development Time

111

DODGING AND BURNING-IN

If a scene contains dark sections of low contrast and simultaneously bright sections of high contrast, the scene really needs to be both compressed and expanded by treating the two sections of the scene somewhat differently.

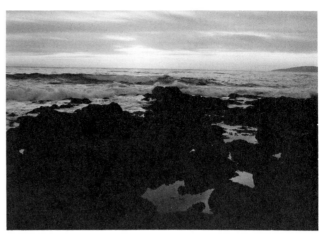

For example, consider a sunset in which the sky is very bright, but the foreground is much darker. Even though the foreground may appear to contain enough light to show detail, in fact the difference in exposure value between the sky and the foreground is so extreme that no amount of compression can decrease this difference enough to hold the entire image when it is printed. Moreover, due to low contrast, the foreground needs expansion, while due to high contrast, the sky needs compression.

The solution to problems of this sort is at best a compromise. First, the scene should be extensively bracketed, with exposures made at half-stop increments over a wide range. The goal is to obtain the best possible negative with which to work.

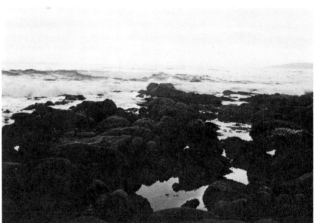

In the darkroom, the film is processed normally. After careful inspection of the developed film, preferably with a magnifying "lupe," the negative that shows the best detail in both highlights and shadows is selected for printing.

In making the print, the procedure involves exposing the lighter section of the negative for a longer time than the darker section. By "dodging" (blocking) light from the dark, foreground sections of the scene, the detail present in the negative will not be overpowered by too long an exposure time. In addition, by allowing the light from the sky portion of the scene to continue exposing the paper, the detail present in those sections of the negative will have an opportunity to "burn-in" on the print.

Dodging and burning-in sections of a print are effective methods for solving particular exposure problems, but the techniques must be exercised carefully. Always present is the danger that the resulting light and dark sections will appear unnatural. For example, in the late afternoon a sky with the sun in it is always substantially lighter than the foreground. Because of this, the scene described above would look strange if the foreground were made nearly as light as the sky.

Dodging and burning-in are relatively easy skills to learn. The most commonly used dodging tool is simply the photographer's hand. Particularly in scenes that include the horizon, a hand can be bent to conform approximately to the shape of the skyline. Otherwise, sheets of black cardboard can be cut to the proper shape. As long as the hand or cardboard is kept moving during the exposure, the dodging tool will not produce a noticeable edge in the print. □

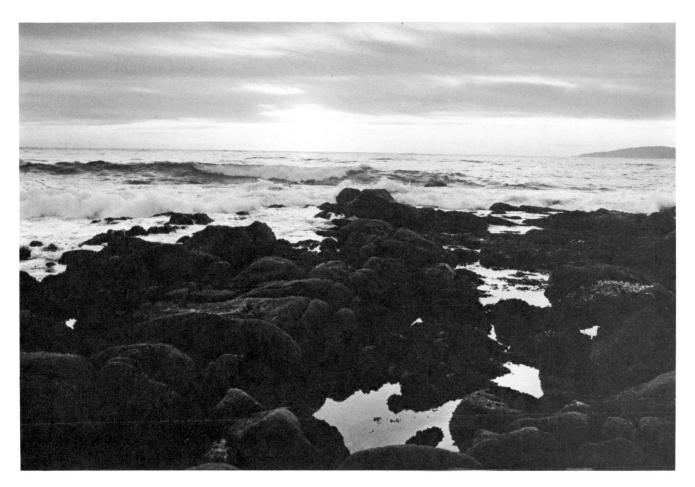

Dodging and burning-in sometimes can be used in conjunction with, or as an alternative to, compression and expansion using the Value Range System.

In dodging and burning-in tones, some of the light from an image is prevented from reaching the paper during part of the exposure time. In the photographs of the California coast shown here, the sky was so much brighter than the foreground rocks that even had the scene been compressed, the tones were too extreme to print both the sky and the foreground rocks with adequate detail.

Therefore, the exposure was bracketed by two half-stops on either side of the exposure indicated by the light meter, and the negative that showed the best detail in the foreground rocks was selected for printing.

Test prints revealed that a printing exposure time of 24 seconds would produce good detail in the sky (top photograph at left), but only 15 seconds of exposure was needed for the rocks (lower photograph at left). Therefore, to make the print directly above, the photographer used his hand to block light from the lower half of the photograph during the final nine seconds of the 24 second exposure time. By keeping his hand moving slightly but constantly, the photographer prevented a sharp line from being formed by the edge of his hand.

The real value of the Value Range System lies in the creative capability it offers a photographer to accurately convert a previsualized image into a final print. By knowing in advance the relationship between meter readings, exposure, development, and tonal rendition in a final print, he can look at a scene, imagine how he would like it to look on paper, and know very quickly what he must do to realize his goal.

The photographs on these two pages illustrate how easy it can be for a photographer to relate what he sees to what he wants. Both photographs are of the same desert and were taken within a few moments of each other. Yet each represents a radically different interpretation of the scene. The Value Range System permitted a quick determination of how to achieve each effect.

At the time these photographs were taken, the measured tonal values in the scene ranged from +3 to −1 on the tonal value scale (shown below each photograph) with the average tonal value being 0 (18-percent gray), of course. In order to interpret the scene as a collection of light tones, it was necessary only to decide what the new range of tones should be. The photographer could easily visualize that a shift in exposure of two f-stops higher on the scale would produce the effect he wanted, so that was what he did. The range of tones in the final print runs from +5 to +1.

Similarly, to interpret the scene as a collection of dark tones, the photographer needed only to visualize how the scene would look if the range of tones ran from 0 to −4. That range seemed to be what he wanted, and the photograph at right is the result. In each case, the process took only a few seconds to complete.

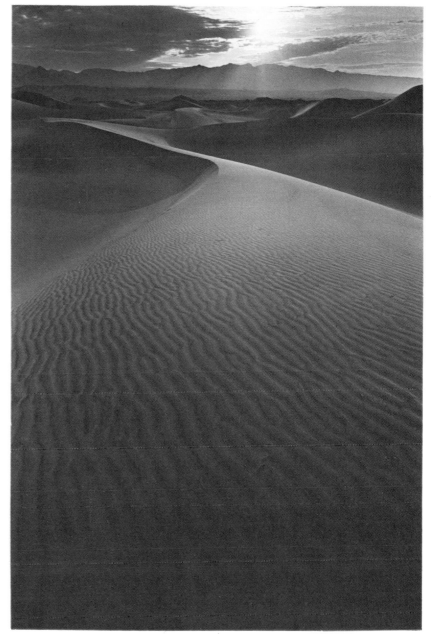

−4 −3 −2 −1 0 +1 +2 +3 +4 +5

PORTFOLIO IV

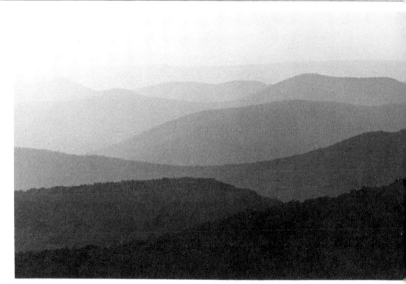

THE VALUE RANGE IMAGE

There are times when the subject itself is so overwhelming that all you want to do is preserve it.

CYPRESS, POINT LOBOS

Even when the only goal in a photograph is to make a visual record of the scene in front of the camera, the Value Range System provides the mechanism for insuring that the desired image ultimately appears on film.

In the photograph at left, the tones of the cypress tree stood out well, to the unaided eye, because of differences between the color of the branches and the background. But the black-and-white tonal values were very similar. Had the photograph been taken without expanding the tones through underexposure and overdevelopment, the branches would not have formed the same striking pattern against the background that caught the photographer's eye.

The situation was exactly the opposite in the photograph at right. Bright sun produced such high contrast that the tones in the scene had to be compressed substantially in order to reproduce the scene faithfully.

LOWER YOSEMITE FALLS

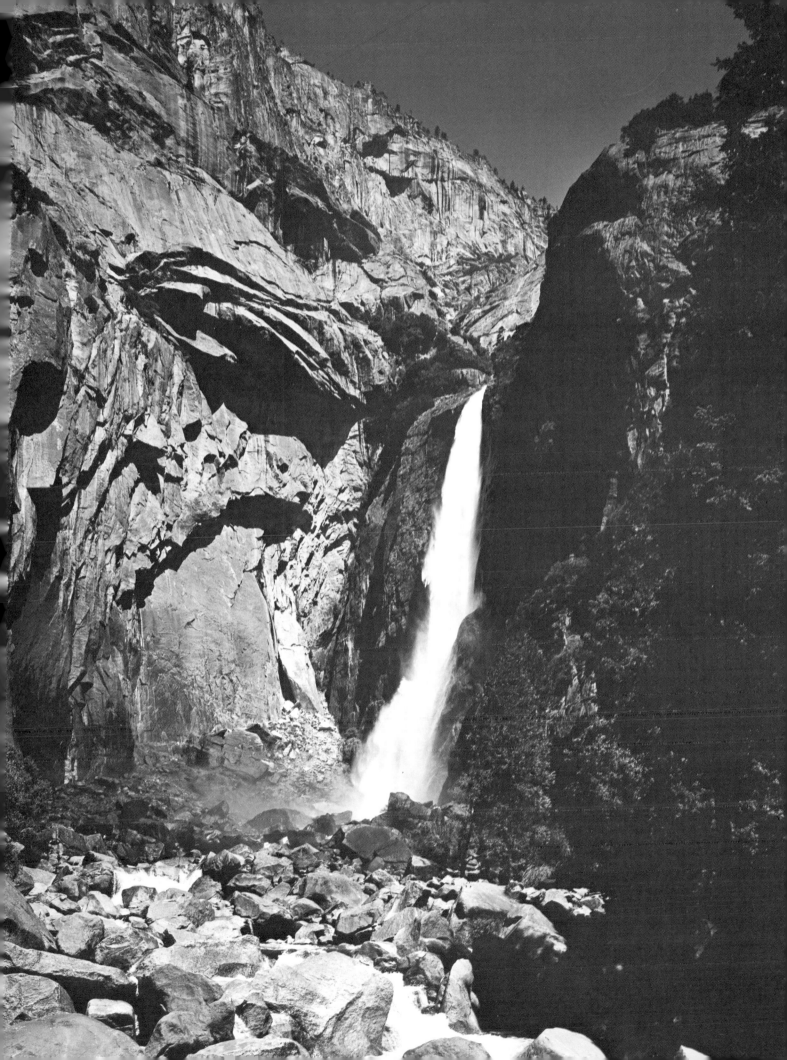

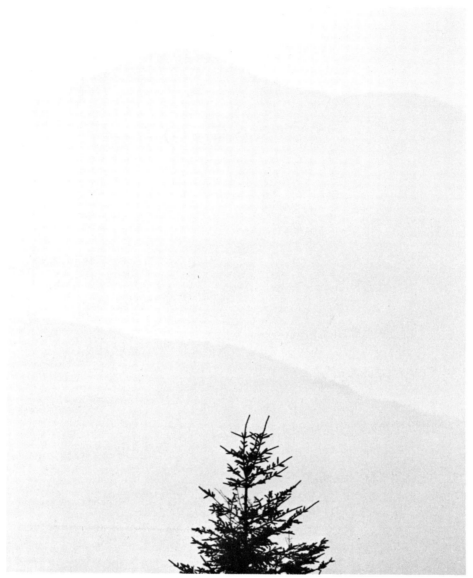

EARLY MORNING MIST IN THE SMOKIES

*T*rue contrast control means being able to manipulate tones at will, even if the intent is to create an image that bears little resemblance to the original scene.

DEAD TREE, ROCKY MOUNTAINS

Sometimes, in order to produce a desired effect, a photographer must expose for an 18-percent gray tone that is not actually present in the scene.

The stark contrast of the tree, above, against the blackened sky was produced by selecting an exposure that would preserve highlight detail. The sky was originally dark blue, and was further darkened through the use of a red filter. The amount of neutral gray in the photograph is extremely limited.

At left, the average tone in the final print again differs significantly from a neutral gray; indeed, there is no neutral gray in the photograph at all. The Value Range System allowed an accurate determination of exposure settings that were different from the settings indicated by the camera's initial through-the-lens meter reading.

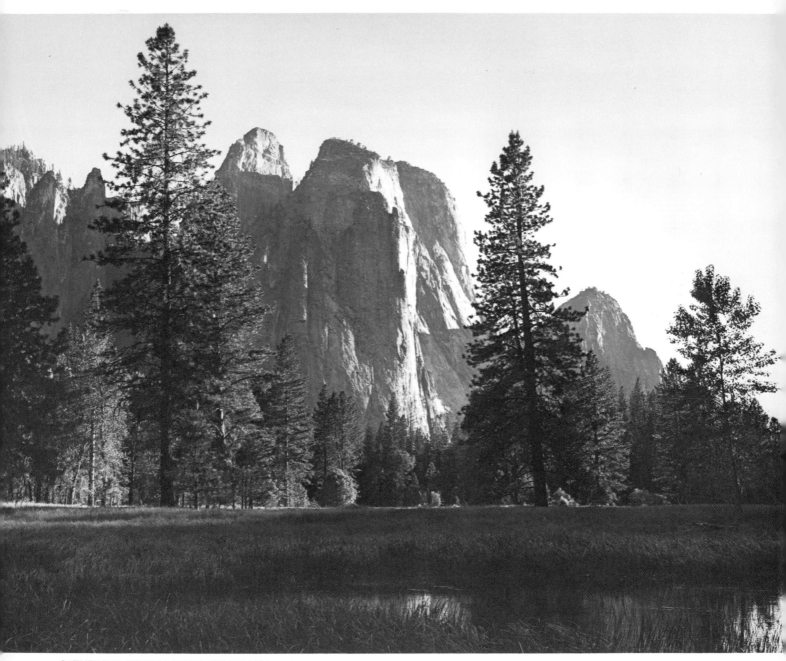

CATHEDRAL ROCKS I, YOSEMITE VALLEY

Sometimes the difference between a commonplace photograph and a dramatic photograph is simply a matter of exposure.

The Value Range System of exposure control permits a photographer to alter his interpretation of a scene easily.

These two photographs were taken within a few moments of each other. In the left photograph, expanding the tones in the scene produced low contrast and a light, airy feeling.

In the right photograph, compressing the tones in the scene resulted in much greater contrast and a darker, heavier feeling.

As is often the case, these two interpretations differ in more than simply tonal range. In the right photograph, due to the loss of shadow detail caused by the compression of tones, the foreground area appears as a large, dark mass. This mass serves as a strong graphic element in the photograph that is emphasized by the manner in which the photograph is cropped.

CATHEDRAL ROCKS II, YOSEMITE VALLEY

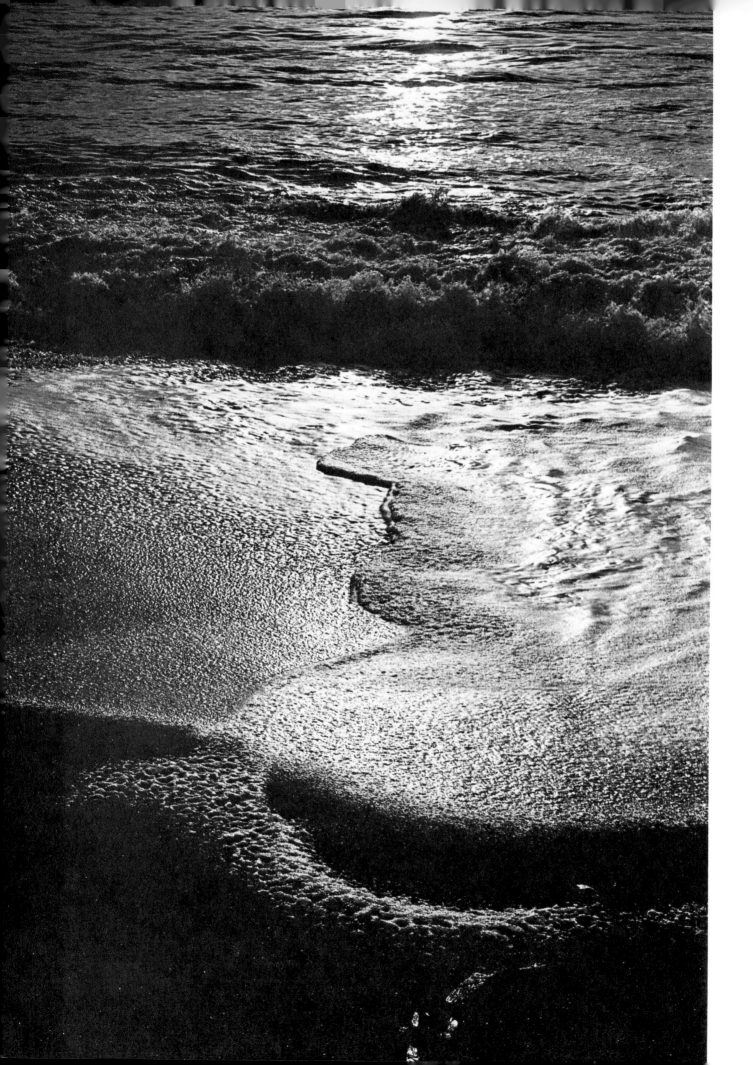

Using a system of exposure and contrast control helps a photographer develop the ability to see photographs within scenes that to the untrained eye do not appear worth expending film on.

At left, the brilliant sun reflecting off the ocean's surface, though overpowering to the eye, submits readily to the moderating effect of the correct exposure.

At right, a "busy" background is thrown into darkness through contrast control, allowing the reed, which otherwise would have been lost against a confusing pattern, to stand out sharply.

REED AND WOOD

SUNSET, POINT LOBOS

T he ability to previsualize tones as they will appear in a black-and-white print is absolutely essential in creative photography.

LIGHT ANGLE

The angle at which light strikes the elements within a scene has a pronounced effect on the way the scene is rendered in a photograph. (This effect is independent of the *quality* of the light, as discussed in Section 3.) The scenic photographer's goal is to take whatever steps he can to ensure that the direction of light in a scene supports the message he wishes to convey.

Contrast in a scenic photograph is often dependent upon the shadows present in (or absent from) a scene. Since the nature and appearance of the shadows are themselves dependent upon the angle along which light enters the scene, contrast and light angle are closely related. Moreover, on a very practical level, shadows serve as contrasting backgrounds for the brighter elements in a photograph.

The position of the camera relative to the sun and the object or scene being photographed determines the extent to which the camera "sees" any shadows that are present. When the sun strikes an object obliquely relative to the camera, the shadow is apparent. When the sun strikes an object directly, that is, from the same angle as the camera is pointed, any shadows which may be formed are usually hidden from view. Of course, as a photographer changes the position of the camera or the direction it is pointing, and as the sun moves in the sky, the appearance of shadows also changes. In addition, the nature (or "quality") of the light varies according to the position of the sun.

Elevation. Changes in the elevation of the sun primarily affect the color and "quality" of the light. Low on the horizon, the light is diffused by atmospheric haze, color is shifted toward the red end of the spectrum, and long shadows are formed. By noontime, the reduced effect of atmospheric haze produces far more contrast (the shadows are darker, relative to the highlights) and most objects are illuminated directly, rather than obliquely.

The elevation of the sun at noon is not constant but varies according to the time of the year and geographic latitude. The higher the latitude and the nearer to the winter solstice (about December 21 in the northern hemisphere, about June 21 in the southern hemisphere), the lower the sun's maximum elevation and the softer the light produced at noon.

Azimuth. The lateral angle of the sun relative to camera and object affects both the overall shadow produced by the object and the extent to which the object's texture is revealed. Customarily, the types of lighting possible are broken into three categories.

•*Frontlight*. Frontlight results when the sun is directly behind the camera. Frontlight is "flat" and usually produces little contrast or detail in a scene. Frontlit scenes generally lack definition and a feeling of depth.

If the sun's elevation is low, sometimes frontlight will produce a slight shadow around an object that will reveal the object's shape to some extent, but typically, frontlight is best avoided in scenic photography.

•*Backlight*. Backlight results when the angle formed by drawing a line along the ground from the camera to an object and then to the sun is between 90 degrees and 180

Frontlight

In frontlight, where the sunlight entering a scene originates from directly behind the camera (or nearly so), few shadows are visible to the camera. The result is usually a lack of definition and contrast.

The photograph at left illustrates the difficulties and shortcomings of front lighting. Taken at high noon, this view of the face of a wall in the Rocky Mountains suffers from not having any center of interest. Because the light illuminates everything evenly, no one element or group of elements stands out. The rocks all melt into one another, so that the eye is not attracted to any one place within the photograph. The shapes that are discernible are uninteresting, and the overall effect is one of confusion. Taken at another time of day, perhaps later in the afternoon, the light might have been entering the scene from the side and the effect would have been entirely different.

At right is an example of one of the rare instances of how front lighting can be used successfully. Even though the light makes the face of Yosemite's Half Dome look flat, it appears as a monolith against contrasting foreground and background. A slight "modeling" effect, similar to that produced by a ring light, helps outline the Dome against the sky.

The primary reason for this photograph's success is its simple composition. Had as many individual elements been evident in this scene as in the one on the opposite page, this scene too would have been visually confusing. As it is, for a few brief moments a large shadow formed by a mountain behind the camera eliminated enough foreground detail at the base of Half Dome to simplify the composition and allow the frontlight to be acceptable.

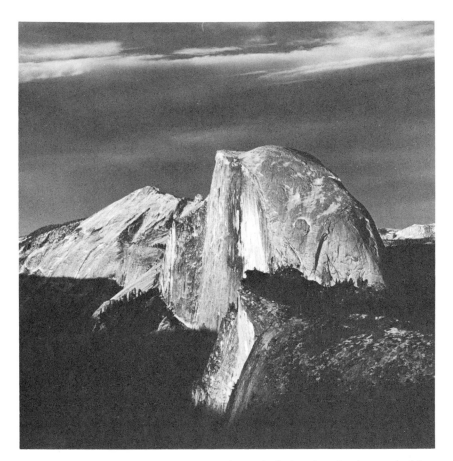

degrees. The sun may be included within the frame, hidden behind an object, or left out entirely.

Because of the sun's location in or near the frame, the lens often must be stopped way down, causing detail to be lost and rendering objects in silhouette. If atmospheric haze is present, contrast in the scene will be significantly lowered. The possibility of lens flare is always high in backlit settings, and therefore flare must be either guarded against or intentionally and creatively incorporated into the photograph.

•*Sidelight*. Sidelight results when the angle formed by drawing an imaginary line extending from the camera to an object to the sun is between about 10 degrees and 90 degrees. Sidelight is especially useful for revealing the contours of objects and their surface texture. The shadows produced by sidelight are very apparent to the camera, especially when the sun is low in the sky. The volume of objects in a sidelight is readily inferred, and the presence of shadows along the ground often provides clues to the scale of a scene. Usually, scenes that appear flat in frontlight become far more interesting when illuminated from the side.

Deriving maximum benefit from light direction usually necessitates careful planning. Often, a particular scene will be illuminated best only within a narrow time frame—and usually that time will occur within an hour or two of dawn or dusk. Not infrequently, the lateral direction of the sun at dawn or dusk will be more advantageous in one season than another. For most photographers, it will not be convenient or even possible to return to a scene in a different season, but a photographer who plans carefully should in most circumstances be able to obtain at least satisfactory results. □

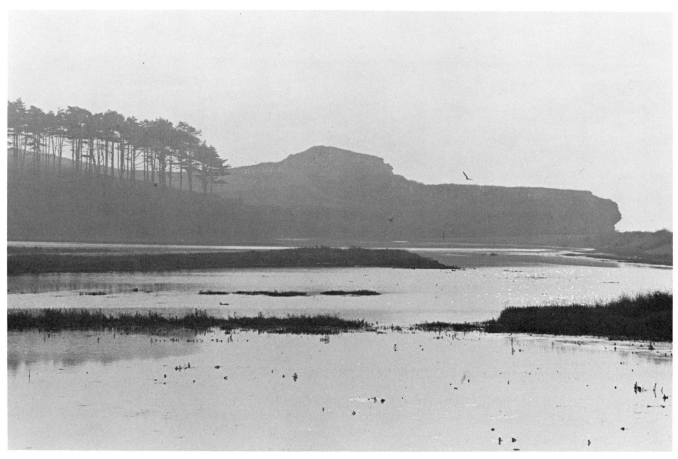

Backlight

In a backlight, because the sun originates from behind the subject, and moisture in the atmosphere disperses light and reduces contrast, the result is often a photograph with a light, airy feeling.

In the above photograph of England's Devon coast, backlight has reduced detail in the distant terrain but emphasized its constituent shape. The photograph achieved its effect primarily through the compositional arrangement of light tones and dark tones.

In some circumstances, however, a backlight can produce high contrast. In the photograph at left, undulations along the surface of the ground create shadows against which individual blades of grass stand out sharply. The combination of sunlight reflected off the blades and these randomly spaced areas of darkness introduce a degree of rich detail unusual in a backlit setting.

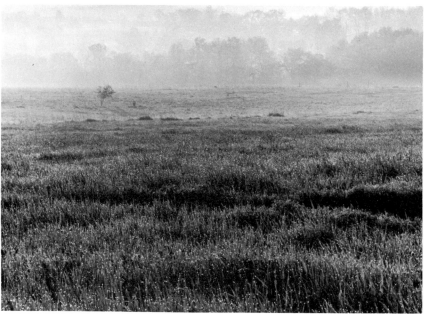

Sidelight

In side lighting, the shape, volume and texture of objects are especially well revealed. To demonstrate the character of surface terrain, early morning or late afternoon sidelight is ideal.

The photograph of Zabriskie Point, Nevada, at right was taken just after sunrise. The rich texture of the foreground rocks is easily discernible, but even the nature of the distant background terrain, diffused as it is by miles of atmospheric haze, is apparent.

A feeling of depth and the scale of the scene is more evident here than in the two photographs on the previous page. Both frontlight and backlight tend to distort the appearance of depth in a photograph, whereas sidelight emphasizes it. The biggest challenge in early morning or late afternoon photography is timing. Conditions change rapidly, and often the best instant to shoot is difficult to anticipate with precision. In taking this photograph, because the shadows were changing moment by moment, the best course was to shoot many frames of film and then later select the best individual exposure.

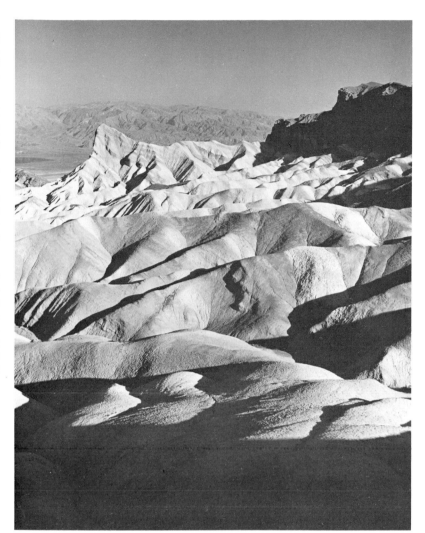

WEATHER

Weather is always a factor in outdoor photography, but in scenic photography weather often is, in effect, the subject. Cloud formations, rain, snow, fog, wind—all can serve as the subject of a photograph directly, or when the subject is actually the *effects* of weather, indirectly.

More often than not, a sky filled with clouds is more interesting than an empty sky, even if filters are used to darken the sky for contrast. Usually, the sky should be used to support a landscape rather than as the subject, but when clouds are especially dramatic they are fitting subjects in their own right.

The pattern of raindrops falling on water is an overworked subject, but rain can be used effectively in other ways. The presence of moisture clinging to leaves, needles, or flowers often adds an extra dimension to close-up photographs. With color film, objects often appear to have more deeply saturated colors when they are wet than when they are dry. Frequently, the approaching end of a brief storm can herald the arrival of an unusual light quality, especially in the late afternoon.

Snow is deceptive to photograph. Unless it is overexposed by one *f*-stop, it will appear gray in a photograph. Moreover, the timing of snowscapes is critical. During a heavy snowstorm, reduced contrast usually requires that a photograph include a strong abstract composition for success. This is fine with black-and-white film. With color, though, to avoid a photograph containing only grays, it is better to wait until the storm is over. Frequently, the best time to photograph snow is after the storm ceases, when the sky often becomes a rich blue and the snow sparkles. In any event, snowscapes should be taken within a day or two of the snowfall while tree branches are still laden.

Fog and mist are excellent for suggesting distance in a photograph. The subtle tones mist generates produce an airy feeling similar to that associated with atmospheric haze. In conjunction with color film and color filters, mist offers a means for creating a monotone effect in a scene. □

The effective use of weather phenomena in a photograph often requires great patience and careful planning.
Without the presence of the cloud, the photograph at right would have been hopelessly dull. The cloud adds both interest and contrast.
However, most of the impact of this photograph results from the way the shape of the cloud echoes the windswept shape of the tree. This is no coincidence. The photographer recognized the importance of the cloud to the composition, maneuvered himself into a position that placed the tree against the lighter background, and waited patiently for the wind to mold the cloud into a pleasing shape.

With imagination, a photographer can turn even miserable weather to advantage.
This photograph was taken in fog during a rainy downpour. The presence of so much moisture in the atmosphere invariably results in lowered contrast; so the trick is to work with shapes and tones, rather than with specific individual elements. The consequence is a photograph that depends for its effect primarily on the juxtaposition of light gray and dark gray tones in an interesting composition.

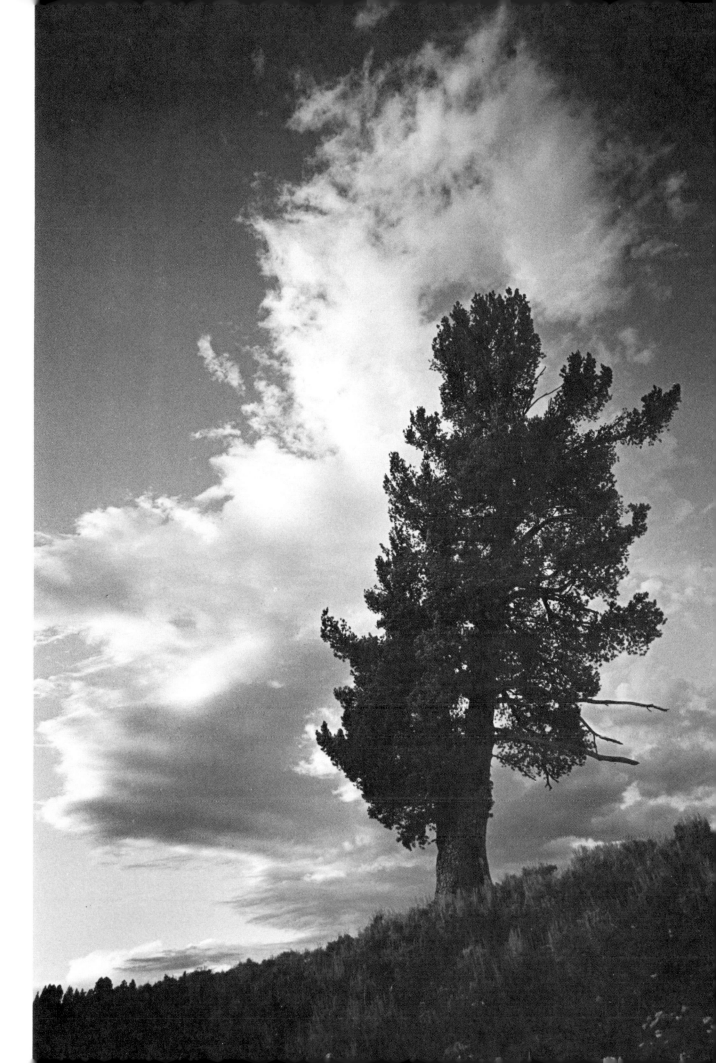

PHOTOGRAPHING IN A FOREST

One of nature's most elegant settings—the floor of a lush, deep forest—can be surprisingly difficult to photograph. While to the unaided eye a woods may seem an appealing setting for photographs on a sunny day, brilliant sunlight is usually the nemesis of forest photographs.

The problem is contrast. Light that reaches the forest floor unobstructed is so much brighter than surrounding shadows that any film's exposure latitude will be exceeded. As a result, if the camera is set to an exposure that will record highlight detail, everything else records as dark blotches. If the exposure is set to record shadows, highlight areas "wash out." In either case, the result is a mottled image that does not do justice to the scene.

Consequently, the best weather condition for woods photography is an overcast sky. The smooth light will not produce contrast extremes. The woods may seem quite dark, but to the film, the important consideration is that the range of light intensities present does not exceed the film's ability to record them. No matter how dark the woods may be, all that is needed is an exposure time long enough to record the image.

Since the long exposures necessary in woods photography almost always mean that the camera must be mounted on a tripod, the film chosen is immaterial. Unless the wind is causing objects to move or the noticeable presence of film grain is desirable, fast films offer no particular advantage over even the slowest fine-grained films.

Although large-scale views of a woods scene are often attractive, a woods is also a rich source for close-up subjects. Mushrooms, leaves, bark, flowers, and plants in general can be used to tell a "story" of the forest or of the seasons. Moreover, such close-up photographs invariably provide excellent practice in achieving a balanced composition.

Depth-of-field control can be important in the woods. For close-up photographs, in many instances, shallow zones of sharp focus are problems that can be minimized by using wide-angle lenses. Conversely, for selectively focusing on some objects while intentionally blurring others, longer lenses provide an advantage.

The same condition that is conducive to photographing in the woods—an overcast sky—can provide an additional benefit if rain is falling. As has been pointed out previously, moisture can enhance the colors of objects and add visual interest. A light drizzle is often the most advantageous type of rain.

Even though a forest is dark, enough light may be filtering down from the sky to produce reflections off foliage and these can reduce color saturation. Therefore, a photographer shooting color film should routinely mount a polarizing filter in such conditions. The presence of the filter will not affect the photograph if no reflections are present, but if some are, it will make a substantial difference. That difference may or may not improve the photograph, but having the filter already mounted will enable you to quickly check the filter's effect on each scene. □

Strong sunlight rarely produces good, or even acceptable, photographs within a forest. Far more useful is the smooth low-contrast light from an overcast sky. In the photograph below, high contrast between patches of sunlight and shadow areas produced a photograph that is difficult to "read." Since the eye is attracted to the area of highest contrast, and that area is confusing, the entire photograph is confusing and the fern is lost.

In the photograph at right, which was taken in the Muir Woods in California during a light drizzle, the even light eliminates the blotchiness apparent in the other photograph and allows the composition to be built clearly around the ferns. The brightness of the ferns relative to the background sorrel is due to a reflection of the sky. A polarizing filter would have reduced the reflection, but it would also have caused the ferns to blend into the background tones.

Even though the photograph at right was taken with the camera being held within 12 inches (30 cm) of the ferns, there is great depth of field because a wide-angle lens was used.

Page 21.
Leica M4 camera. 50mm Summicron lens. 1/30 sec. at ƒ/11. Kodak Plus-X film rated at ISO 125/22. Slightly overdeveloped in Kodak D-76. Agfa Brovira No. 2 paper.

What I wanted to capture was the loneliness of the tree. Since tones that are so light that they are about to disappear have a very fragile feel in a print, I shot this scene at two ƒ-stops above the incident-light meter reading, and then underdeveloped the film slightly. In printing, I selected an exposure that would print the tree as a dark gray. I held a diffusion filter in front of the enlarger lens to add a touch of softness to the image. The final print is much lighter than the actual scene was.

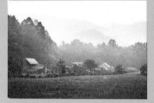

Page 21.
Nikon camera. 200mm Nikkor lens. 1/60 sec. at ƒ/8. Kodak Plus-X film rated at ISO 125/22. Normal development in Kodak D-76. Agfa Brovira No. 2 paper.

In this scene I wanted to show the delicate beauty of early morning fog on a rainy day. Overexposing the film kept the scene light, but by limiting the amount of overexposure to only one stop, I avoided making the scene appear unnaturally light.

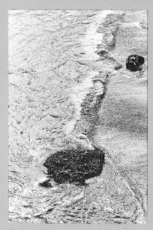

Page 22.
Leica M4 camera. 90mm Summicron lens. 1/125 sec. at

ƒ/16. Agfapan 100 film. Normal development in Rodinal. Agfa Brovira No. 2 paper.

This was a very difficult scene to meter because the average tone in the scene was very bright. I wanted to retain the silvery feeling of the water's surface, but I knew that a reflected-light reading off the water would have produced a predominantly gray tone. Taking an incident-light reading directly into the sun produced exactly the right exposure.

I used Agfa film for this shot because I wanted the extra bit of sharpness and contrast Agfa films provide.

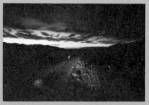

Page 23.
Leica M4 camera. 21mm Summicron lens. 10 sec. at ƒ/8. Kodak Plus-X film rated at ISO 125/22. Agfa Brovira No. 3 paper.

While driving along a back road after a full day of shooting. I didn't really expect to see anything that I would want to photograph. I was tired. The sun had set and the landscape had fallen into darkness. Then suddenly the pattern of shrubbery illuminated by my car's headlights caught my eye, so I slowed the car and took some light readings.

By luck, a reflected-light reading of the sky matched the incident-light reading of the headlights, so I knew that light from both sources would record with equal intensity on the film. Later, in the darkroom, the image looked a little weak on No. 2 paper. Reprinting on No. 3 paper livened up the scene by just the right amount.

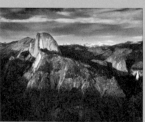

Page 24–25.
Hasselblad camera. 50mm Sonnar lens with red filter. 1/15 sec. at ƒ/16. Kodak Plus-X film rated at ISO 90/20.5. D-76 developer. Agfa Brovira No. 2 paper.

When I first arrived at this scene, I was worried because the upper section of Half Dome didn't

contrast well against either the sky or the lower section of the mountain. Moreover, the sun was falling fast, and so the exposure was changing fast.

I was able to solve the contrast problem by timing the shot carefully so that the shadow rapidly climbing up the foot of Half Dome would be in the best position to darken the foreground. The red filter didn't darken the sky sufficiently, so I burned it in later during printing.

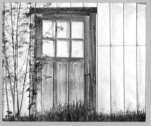

Page 26.
Leica M4 camera. 90mm Summicron lens. 1/125 sec. at ƒ/16. Kodak Plus-X film rated at ISO 125/22. Normal development in Kodak D-76. Agfa Brovira No. 2 paper.

I knew that in order to reproduce the overall light tones in this scene, I could not rely on a reflected-light reading. Instead, I took an incident-light reading directed at the sun. That reading turned out to be perfect, and the light tones were maintained without the need for any special treatment of film or print. The incident-light reading turned out to be 1½ stops lighter than the reflected-light reading.

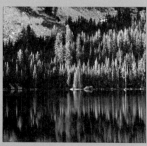

Page 27.
Hasselblad camera. 150mm Sonnar lens. ¼ sec. at ƒ/11. Kodak Plus-X film rated at ISO 90/20.5. Agfa Brovira No. 2.

The sun was striking this scene from a 90-degree angle with a harshness I knew would cause contrast problems. Part of the solution was to compose the photograph so as to crop out some of the areas of greatest contrast, and also to compress the tones enough to preserve shadow and highlight detail. Since I was too far away from the scene to take a meaningful reflected reading of the shadow areas, I

took two incident-light measurements: one with the meter pointing directly into the sun, one with the meter pointing in exactly the opposite direction. I exposed the film at a setting intermediate between the two readings. I rated the film at ISO 90/20.5, and developed for three-quarters of my normal time.

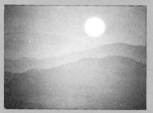

Page 50.
Nikon camera. 200mm Nikkor lens with TC 200 X teleconverter. 1/60 sec. at ƒ/5.6. Kodachrome 25 film.

The sun was well filtered by atmospheric haze, so I was able to take a through-the-lens meter reading with the sun visible in the lower corner of the viewfinder. There was so much haze present in the developed transparency that the mountains appeared a little paler than I wanted, so I duplicated the original transparency onto Kodachrome 25 film using a Bowens Illumitran to boost contrast slightly.

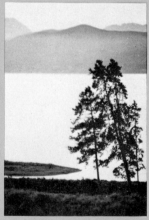

Page 51.
Nikon camera. 200mm Nikkor lens with Spiratone red Colorflo⁶ filter and polarizer. 1/15 sec. at ƒ-8. Kodachrome 25 film.

Usually, knowing that the colors in a scene generally lose some intensity on film, I like to add a slight amount of color artificially. I try to avoid making the added color overpowering. Here, I added more color than usual because there was so little color actually present in the scene and because I felt the deep color would help to emphasize the visual pattern formed by the scene's elements.

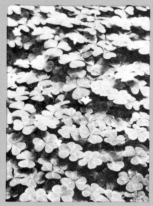

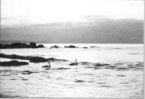

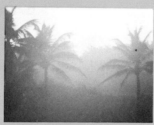

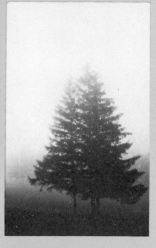

reading of the side of the subject facing the camera. I open up my lens one stop for the first exposure, and then bracket (on the overexposed side only) in half-stop increments. For this shot, the first exposure turned out to be the best.

Page 51.
Nikon camera. 20mm Nikkor lens with polarizer. ¼ sec. at f/11. Kodachrome 25 film.

The most unusual aspect of this photograph is the use of a 20mm lens to create an extremely sharp image and a feeling of expansiveness. I had to mount the camera low to the ground in a somewhat awkward position, but a longer lens simply would not have produced the same visual effect, and would not have included so many individual plants within the frame. In addition, the short lens stopped far down was important for maintaining razor sharpness all the way to the edges of the frame.

Page 53.
Nikon camera. 55mm Micro-Nikkor lens. 1/30 sec. at f/8. Kodachrome 25 film.

A few conflicting elements complicated this shot. I needed to use a small f-stop to get a broad depth of field, but I also needed to use a fast shutter speed to freeze the movement of the swans as they swam through the waves. In addition, the swans were far away and therefore I wanted to silhouette them against the sun's reflection so that they would be prominent in the frame.

Ultimately, even though usually I don't like to shoot at a shutter speed slower than 1/125 sec., I had to settle for 1/30 sec. But I had studied the swans' movement for a while, and had noticed that each time a wave passed under them, there was an instant when the swans seemed to lie motionless in the water. I had to wait for a long time, but eventually the swans' position relative to the sun coincided perfectly with the motion-stopping effects of a wave.

Page 54.
Nikon camera. 200mm Nikkor lens with TC 200 X teleconverter. 1/125 sec. at f/5.6. Kodachrome 64 film.

Because it is easy to lose the image entirely except within a narrow range of exposures, I always bracket widely when shooting directly into a hot sun—especially when I am relying on a through-the-lens meter reading.

For this photograph, I took my reading with the sun outside the viewfinder, then bracketed three f-stops up, that is, lighter, in half-stop increments. The golden color results mostly from lens flare.

Page 56.
Nikon camera. 500mm mirror reflex lens. 1/60 sec. at f/8. Kodachrome 25 film.

Shots that include the ball of the sun are always tricky and require bracketing, but only on the overexposure side of the indicated exposure. This is because the sun is so bright that the exposure indicated by the meter invariably throws foreground detail into silhouette.

In this shot, the bracket one stop lighter than the indicated exposure held the image of the sun but lightened the scene enough to convey the feel of early morning fog.

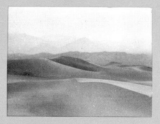

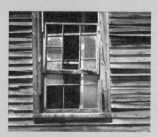

Page 52.
Nikon camera. 35mm Nikkor lens with polarizer. 2 sec. at f/8. Kodachrome 25 film.

The angle at which the shot is taken can make all the difference when you are shooting waterfalls. For this shot I had to set the tripod in the water in order to lower the camera far enough to be able to pick up a green reflection from the foliage above. At an exposure time of two seconds, I had to open the lens one f-stop to compensate for reciprocity failure. The polarizer removed the sheen from the rocks, created by water splashing on them, but, because of the angle involved, didn't affect the reflection in the water.

Page 54.
Nikon camera. 200mm Nikkor lens. 1/125 sec. at f/5.6. Kodachrome 25 film.

Any time you're shooting in backlight, obtaining meaningful meter readings can be tricky. An incident-light reading of the sun will usually be accurate, but what I often do is to move in close to the subject, if I can, and take a close-up, through-the-lens

Page 54–55.
Nikon camera. 55mm Micro-Nikkor lens with Spiratone red Colorflo⁰ filter. ⅛ sec. at between f/8 and f/11. Kodachrome 25 film.

As soon as I saw this scene I knew I wanted a high-key effect; that is, I wanted the average tone in the scene to be lighter than 18-percent gray. To be sure I'd be able to get the shot I wanted, I bracketed up from the through-the-lens meter reading by half stops.

There's really no "best" exposure in a backlight. In this case, the exposure I liked best turned out to be the lightest one that was possible without losing the image entirely.

Page 90.
Toyo Field 45A camera. Rodenstock Sironar-N 150mm lens. 1/30 sec. at f/64. Kodak Tri-X film rated at ISO 400/27. D-76 developer. Agfa Brovira No. 2 paper.

This was an entirely straightforward scene to photograph. The light was not extreme, so contrast was normal. Since I wanted a full range of tones, I just shot at the exposure indicated by an incident reading—which was identical to the reflected reading. My only "creative" contributions were in deciding to photograph the scene in the first place, and in arranging the composition.

Page 91.
Leica M4 camera. 90mm Summicron lens. 1/60 sec. at *f*/16. Agfapan 100 film rated at ISO 125/22. Rodinal developer. Agfa Brovira No. 2 paper.

At first glance, this scene appeared as easy to photograph as the one above. The potential problem was not contrast, but sharpness. The scene was brightly lit, so it would have been easy to assume that the shutter speed would have been fast enough to permit me to handhold the camera. But on 35mm film, that would have meant sacrificing depth of field.

By using a tripod so that I could stop the lens down all the way, I was able to produce an image that can compete with one from a large-format camera for sharpness.

Page 92.
Hasselblad camera. 150mm Distagon lens with extension tubes. 10 seconds at *f*/22. Kodak Plus-X film rated at ISO 90/20.5. D-76 developer. Agfa Brovira No. 2 paper.

Patchy light filtering through the trees was hitting part of this flower directly, while another part was in shadow. To make the light more even, I propped a sheet of white paper on either side of the flower to reflect light onto it.

The presence of the extension tubes required that I open the lens one and one-half stops beyond the meter reading, and the effects of reciprocity failure called for an additional stop, for a total increase in exposure of two and one-half stops.

In printing the image, I burned in the background slightly to throw more emphasis on the flower.

Page 93.
Nikon camera. 55mm Micro-Nikkor lens with polarizer. 8 seconds at *f*/16. Kodachrome 25 film.

I knew the appeal of this scene would be dependent upon richness of color; so I bracketed exposures carefully to be sure to obtain the deepest greens possible. To compensate for reciprocity failure, I opened the lens one stop wider than indicated by the meter reading.

To protect the camera from dripping water, I covered everything but the front of the lens with a plastic bag. To keep myself dry, I used the camera's self-timer so that I could stay back from the drips as much as possible.

Page 93.
Nikon camera. 55mm Micro-Nikkor lens. 1/30 sec. at *f*/8. Kodachrome 25 film.

The muted colors in this shot result from its having been taken in open shade. Because the scene was so evenly lit, the camera's through-the-lens meter yielded a perfect exposure.

Page 94.
Nikon camera. 105mm Nikkor lens. 1/125 sec. at *f*/2.8. Kodachrome 25 film.

The background of this shot was unattractive and confusing. A narrow depth of field produced a background blur that ended up as a pleasing abstract pattern.

Page 94.
Nikon camera. 24mm Nikkor lens. ¼ sec. at *f*/8. Kodachrome 25 film.

In this scene my goal was exactly the opposite of my goal in the previous photograph: I wanted extreme sharpness. Even though the scene lies mostly along a single plane, I wanted to be sure to show the texture of the rock. The short lens set at *f*/8 was sufficient.

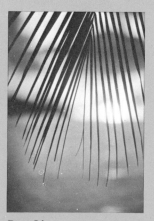

Page 94.
Nikon camera. 200mm setting of Nikkor zoom lens with Spiratone Colorflo® filter and polarizer. 1/60 sec. at *f*/5.6. Kodachrome 25 film.

The primary technical point in this photograph is the effect of the lens aperture on the sun. By choosing a wide *f*-stop and thereby throwing the sun out of focus, I made it appear larger in the frame. The red filter enhanced the sunrise effect.

Page 95.
Nikon camera. 55mm Micro-Nikkor lens. 1/15 sec. at *f*/5.6. Kodachrome 25 film.

At the time I was taking this shot, I was in the middle of an open field watching a beautiful sunrise, but I couldn't see anything interesting to use as a subject. Suddenly, I noticed the dew drops on the grass, and dropped down low to the ground to see if they could form the basis of the shot.

Looking through the viewfinder with my lens on its macro setting, and constantly using the preview button to monitor depth of field, I studied the close-up scene until I noticed that the drops contained the larger scene within them.

In order to get low enough to the ground, I had to mount the central pole of my tripod upside down on the tripod legs.

Page 96.
Nikon camera. 500mm mirror reflex lens with Spiratone red CF/U filter and polarizer. 1/60 sec. at *f*/8. Kodachrome 25 film.

Motion blur is hard to control with long lenses, and especially

with reflex lenses, and so I used two tripods here: one for the lens and one for the camera. Even so, the effects of camera shake and a slight breeze combined to blur the leaves slightly.

The filter I used was handmade. I cut a circle out of the CF/U filter and mounted the circle in the special filter holder built into the back of the lens. By rotating the polarizer mounted on the front of the lens, I was able to produce a weak magenta color that supplemented the soft, delicate pattern of the leaves.

Page 120.
Leica M4. 90mm Summicron lens. 1/60 sec. at f/11. Kodak Plus-X film rated at ISO 125/22. Overdeveloped one stop in D-76 developer. Agfa Brovira No. 2 paper.

This scene was difficult to meter, primarily because regulations did not permit me to move close enough to the tree to take accurate readings of the tree and background. Fortunately, I had a spot meter with me that worked well. In the darkroom, I burned in the foreground to prevent it from competing with the tree.

Underexposure and overdevelopment separated the tones of the tree from those of the background.

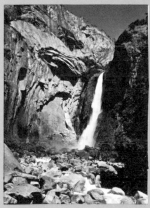

Page 121.
Omega View 45D camera. 75mm Rodenstock Grandagon lens. 1/15 sec. at f/45. Kodak Tri-X film rated at ISO 400/27. Underdeveloped one-stop in D-76 developer. Agfa Brovira No. 2 paper.

Timing was critical for this photograph. When I first reached this scene, it was mostly in

shadow. I set up the camera at once, made all the needed adjustments (specifically a front forward tilt), and waited. As the sunlight progressed along the surface of the rock, I took many spot readings and determined that it would be best to overexpose by one stop and develop at two-thirds of my normal time.

I took the shot just when the sunlight made the waterfall the brightest object in the scene.

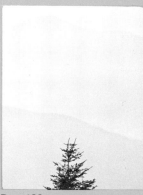

Page 122.
Leica M4 camera. 90mm Summicron lens. 1 second at f/8. Kodak Plus-X film. D-76 developer. Agfa Brovira No. 2 paper.

In order to print the background mountains in this photograph as light as they are, I had to open the camera one stop wider than indicated by the incident reading. Using the incident reading would have rendered the mountains with too dark a gray tone. The tree was sufficiently dark compared to the mountains that it still printed dark enough even with the lens opened up.

Page 123.
Leica M4 camera. 35 mm Summicron lens with red filter. 1/60 sec. at f/16. Kodak Plus-X film rated at ISO 125/22. D-76 developer. Agfa Brovira No. 2 paper.

Exposing this scene normally would have caused the bright highlights in the tree to wash out entirely. Since I wanted the tree to be recorded with normal tones, I exposed the film at one stop darker than the incident reading. The sky went black because of the combined effects of high altitude, which makes the sky a deeper than usual blue, and the red filter.

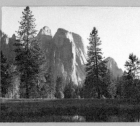

Page 124.
Hasselblad camera. 60mm Distagon lens. ¼ sec. at f/22. Kodak Plus-X film rated at ISO 90/20.5. Underdeveloped by one stop in D-76 developer. Agfa Brovira No. 1 paper.

My goal was to preserve all of the tones in this scene, and to reproduce the feel of late evening light. Because there was a wide separation between the highlights and shadows, I knew I would have to compress the scene greatly.

I overexposed the film by one stop, developed at two-thirds of normal time, and further compressed the tones by printing on No. 1 paper. The result is an image that extends the compression capacity of 2¼-square film to its limits.

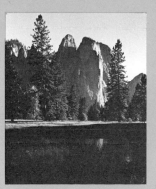

Page 125.
Leica M4 camera. 35mm Summicron lens. 1/15 sec. at f/16. Kodak Plus-X film rated at ISO 125/22. Overdeveloped by one stop in D-76 developer. Agfa Brovira No. 3 paper.

This is the same scene as the previous one, but taken on a different camera and exposed differently.

In this instance, the exposure was normal, but the film was overdeveloped instead of underdeveloped, and the tones were further expanded by printing on high-contrast paper. By selecting a printing exposure that would render the highlights as normal tones, I caused what little detail that was present in the shadow areas to go completely black. Anticipating the different visual balance these dark areas would make, I composed the scene differently in the viewfinder.

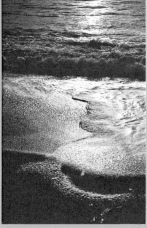

Page 126.
Leica M4 camera. 90mm Summicron lens. 1/125 sec. at f/11. Agfapan 100 film. Rodinal developer. Agfa Brovira No. 3 paper.

I was looking for a high-contrast print with a sharp separation between highlights and shadows, so I chose Agfa film and printed on No. 3 paper. This is the type of scene where I could have manipulated exposure, development, and printing paper to achieve a wide range of different but equally valid tonal ranges.

Page 127.
Leica M2 camera. 90mm. Summicron lens. 1/125 sec. at f/16. Kodak Plus-X film. D-76 developer. Agfa Brovira No. 2 paper.

In this scene I found it difficult to determine exactly what to do to get the tones I wanted. The problem was that the reed was so thin that it was almost impossible to read directly.

I ended up taking a reading off the back of my hand, positioned so that it reflected approximately the same amount of light as the reed. I exposed the scene at that reading, then fine-tuned the tone of the reed in the final print by adjusting the enlarger's exposure time.

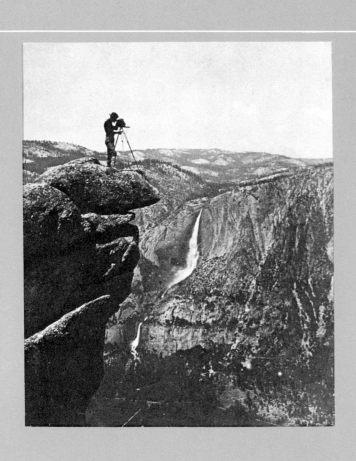

INDEX